En souvenir des bons moments passés ensemble.
À Antonio, Lillian, ChienHui et MuChao

———— de Peggy ChiuLan LIU

意象・藝象

蘇一仲畫作品味析論

蘇 序

　　這本關於我的畫作品味分析，取名《意象‧藝象》，忠實地詮釋個人 2016 年至 2019 年的創作理念，特別是我所追尋的「形」與「意」。從事繪畫是個偶然，一開始只是單純地想在線條與色彩之間讓自己得到舒緩 。 然而，在藝術的世界裡，我不斷地開拓創作材料，探求新技法和渴求作品意境，使得我從不滿足作品現況，設法突破創作困境和瓶頸。當然，我也飽嚐面對一張紙時，孤獨對我極盡冷漠的侵蝕！

　　無疑地，遊戲於筆、墨、形、意之間，不為標新立異，更不期待掌聲，只為解放心、靈的想法和情感；任性地享受讓自己沉醉在「空」，赤裸裸面對自己的那份決然。而這些媒材和長久以來醞釀在思維中的文化，竟就這麼忠實地為我內心赤誠的生命能量吶喊、發聲！不斷地激起我推翻陳舊，創新思維的勇氣和意志力。震撼、感動常在創作中，每每讓我無法自已！在幻化的創作裡，我有機會發掘更深處的 Antonio，抑或，遇見另一位似曾相識的蘇一仲！

　　這本書即將付梓之際，首先我要感謝和泰興業家庭對我的支持與愛護，臺北市美好人生協會及好友們對我的鼓勵與關心！尤其謝謝我的秘書浩齡、護士、司機及國立臺北科技大學劉秋蘭老師、劉國明老師、芊卉、沐昭不畏艱難地與我一起編輯這本書。更要謝謝藝術家出版社協助，以及讀者們，無論舊識或素未謀面，因為這本書，走進 Antonio 的繪畫世界，與我分享藝術人文的饗宴。

　　寫在意象‧藝象之前。

蘇一仲　Soo Antonio

目　次

Table of Contents

A Commentary on the Painting by Antonio Soo

導　論

———————————————————

導 論

和泰興業董事長，也許是畫家蘇一仲更為人所知的頭銜；但商場並不是他生命中唯一豐饒的園圃。戲劇、文學、電影、音樂、美術、甚至魔術戲法，一切有血有肉、有情有味的「美」的事物，尤其是閱讀，一直都在他忙碌生活中，持續性地佔去幾分興致。中國人喜用「雅興」一詞妝點這種興致；但雅也好、俗也罷，這對畫家從來無關宏旨。藝術中赤誠的生命能量，才是讓他心馳神往、甚至自甘一頭栽入的主因。他約於 2014 年開始作畫，繪畫生涯起步雖晚，但豐厚的文化底蘊、敏銳的洞悉能力、不嗜因循蹈軌、熱愛自由和獨立思考特質，對習作狂熾的熱忱，使得他短期內掌握住材質特性、熟稔畫派畫風、樹立獨樹一幟的風格與品味。五年內豐碩的產出、技法提升的痕跡，均是畫家頂得住千鈞之冕，也操得起五彩大筆的證明。

在不長的時間跨度裡，其作品主題卻呈現驚人的廣度，著實是縱橫中外、苞總古今。從《西遊記》到佛典，貝多芬到孫中山，再從美國感恩節的火雞赦免儀式，到布袋戲大師陳錫煌的掌中人生，畫家包山包海的涉獵，悉成為入畫題材。它們並不只是森然羅列的浮光掠影——落筆即是發聲，畫家的畫中永遠有自己的一份聲量。《紅盒子》，讓我們看到畫家對文化議題措意甚深的一面；《祈福之後》，則是一雙社會觀察之眼對假道學的嘲弄。收束至個人經驗，也有如《搶鏡頭》這樣的記趣小品，那是赤子之心才能銘記長久的漏網鏡頭。身兼企業家的社會經驗與開放思維，豐富了他的所見所歷；但那顆善體生活百味的心、對世界恆不失卻的笑罵之忱，才真正豐富了畫家的畫布，使其作品永遠與人生同此脈動、同此鼻息。畫家豐沛的創作思維、脈絡與作品，深刻的美學品味、哲思，及獨特的創作載體，皆已構成一定質量研究指標。本書取法近代西方藝術史與理論研究學者福西永（Henri Focillon）、沃夫林（Heinrich Wölfflin）、潘諾夫斯基（Erwin Panofsky）、佛洛伊德（Sigmund Freud）、貢布里希（Ernst Hans Josef Gombrich）的理論與研究方法，探究與解析畫家藝術品味。

一、形

在本章節中，我們以法國藝術史學家福西永（Henri Focillon）[1] 的形式論述起始，先揭示闢章論形之必要，以及客觀形式事實如何趨向穩定、卒成一格──亦即形成風格的「法源」何所從來。福西永「藝術首先是形式，意義賦予悉屬第二重」的觀點，亦是本文形先意後的布局依據。其次將「形」析為線條與結構、色彩、材質數點，分節申說。

（一）形式生命

本文將形、意對舉，援「視覺、物質性／非視覺、概念性」為判準作簡要二分，乃是為快速掌握畫家藝術語言所使用的權宜架構。但我們也須警醒於這些語彙的界說議題，例如：何謂藝術的「形式」？它相對於什麼被提出？福西永以詩意文字寫就《形式的生命》（Vie des formes）一書，如書名所述，本書淋漓盡致地描繪了福西永對「形式」的慧見──與其說是學理性的定義，毋寧說是文學性的描繪。他不斷提醒讀者：在藝術作品中，作品即是形式。形式不是我們可以從作品中剝離而論的部分，而是藝術得以成立的全般。

我們藉由察看形式來提煉風格，然則形式與風格的關係又是如何？自然，風格即是形式的組合。形式的變形永無止盡，當它合於一套自律的、和諧的基本原理而落定下來，即成風格。但形式總在自我更新，風格亦因此在成立與擺脫的輪轉中演化。福西永致力將風格從種族、環境、時代等外因的律力中解放。那麼風格、形式發展的內律何所持存？除了強調材料、工具與手的交互作用，他更提出「精神人種」的概念。個體心靈汜泳過時空的汪洋而同氣相求，找到自己歸屬的精神家族；太容易為歷史意象所湮沒的精神自由，在福西永筆下重新煥發光明。

福西永的另一個洞見，在提出「材料的天職」。當形式法則發聲召喚某種「效果」，能堪當此任的材料便應制登場，開始其藝術生命。如此，即便福西永幫形式抖落了種族、環境、時代枷鎖，在茫茫史海中指認出心靈共振的波頻，「材料的形式天職」是否仍不免走上宿命論一途？他提醒我們，形式與材料的影響乃是雙向的。材料的稟賦對形式有暗示性和引導性，但形式同樣能敦促藝術家去操縱、改變材料。此番高論，使我們在考察畫家與材質的共作歷程時，得以更加持平以觀。

福西永的形式論，幫助我們在進入形式分析實務前，先對形式的意義作一反思。他固以藝術史眼光宏觀談論「形式生命」，那細膩哲思中揭陳的形式本質卻足為啟發，喚醒我們對形式之自足生命的重視。並引領我們走入那個材料、技術、匠心與巧手相諧，物質與精神合一的藝術世界。

[1] 亨利・福西永（Henri Focillon，1881 年 9 月 7 日－1943 年 3 月 3 日），法國藝術史學家，曾執教於法國里昂大學、索邦大學、美國耶魯大學。以其中世紀藝術論著聞名。

（二）線條與結構

瑞士藝術史學家沃夫林 (Heinrich Wölfflin)[2] 嘗以「線性／繪畫性」這對藝術基本概念，描述文藝復興至巴洛克的畫風革變。至十九世紀末以降，現代繪畫似又重拾、甚至可說是凸出對線條的重視，此與塞尚 (Paul Cézanne)[3] 伊始的幾何解構十分相關，藝術家開始關照線條在造型功能之外的特質。線條未必為顯性筆觸，它代表的乃是一種觀察世界的方式——事物在線條中被框範、定型、自成一閉鎖且確鑿的獨體。

線條功能是多樣的：勾畫輪廓、盪開質感、營造律動、也導引視線。平滑或蹇澀，粗滯或纖細，筆直或纏迴，均聯覺性地喚起心理感受差異。運筆熟稔者能善加駕馭線條品質，下筆均有主意，青澀者則往往只暇關注始末兩端，在此到彼間舉步維艱地挺進。縱觀畫家作品，我們不諱指出，《藍眼淚》的線條仍有得心而未應手的拘謹。但他沒有在這種拘謹中打轉太久，快速掌控了運筆的勁力與心法，並摸索出一套屬於自己的線條風格。

線描——即以顯性輪廓線勾勒物形——是畫家情有獨鍾的手法之一，在《老人與貓》、《黑美人》中最為鮮明。這是一種簡化策略，以貼近素樸心理直覺的方式建構世界，是向原初感官本能的歸返，是棄絕邏輯語言、牙牙說起粗糙但真淳的童語。從後印象派的梵谷 (Vincent Willem van Gogh)[4]，到其所受啟發良多的表現主義畫家如莫迪里亞尼 (Amedeo Modigliani)[5]、野獸派畫家如馬諦斯 (Henri Émile Benoît Matisse)[6] 等，均以這種語言與他們的精神家族遙相感召。相同的兩幅畫，尚呈現畫家對線條暴力美學的偏愛。如若線條是顯性的，畫家便極騁其奇崛不羈，務使其以頓挫、不自然的姿態自我張揚。平滑在畫家的字典裡，似乎異於無趣幾希，有失浪花撞上礁石的激情與浪漫。又如同在《吶喊》中，輪廓線全然退隱。畫家有意襲用孟克 (Edvard Munch)[7] 筆下的彎曲線條，但孟克所精心經營的、渦流般的緻密力場，被抽換為圓與線等幾何單位。在畫家的乾筆狂塗下，組成一種極簡、故也極粗暴的視覺效果。

2 海因里希・沃夫林（Heinrich Wölfflin，1864 年 6 月 21 日－1945 年 7 月 19 日），瑞士藝術史學家。他在《藝術史基本概念》（Principles of Art History）中提到五組對立的概念，區分文藝復興與巴洛克藝術風格之特質，對二十世紀初藝術史形式分析有重大影響。

3 保羅・塞尚（Paul Cézanne，1839 年 1 月 19 日－1906 年 10 月 22 日），法國後印象派畫家，著力探索物象的簡化、體積感的表現，故被視為立體主義遠祖。

4 文森・威廉・梵谷（Vincent Willem van Gogh，1853 年 3 月 30 日－1890 年 7 月 29 日），荷蘭後印象派畫家，表現主義先驅，影響野獸派、德國表現主義尤深。

5 亞美迪歐・莫迪里亞尼（Amedeo Modigliani，1884 年 7 月 12 日－1920 年 1 月 24 日），義大利藝術家、畫家和雕塑家，表現主義代表藝術家，以其線條優美、色彩素雅的肖像畫及裸女畫聞名。

6 亨利・馬諦斯（Henri Émile Benoît Matisse，1869 年 12 月 31 日－1954 年 11 月 3 日），法國畫家、雕塑家、版畫家，野獸派創始人及代表人物，以大膽的色彩、不羈的線條為其標誌。

7 愛德華・孟克（Edvard Munch，1863 年 12 月 12 日－1944 年 1 月 23 日），挪威表現主義畫家、版畫家畫家。

在一些畫作中，線條是重要的裝飾元素，《勾勾纏》、《綠女人》即然。在前者，紋線嵌入作品，與形象、構圖貼合著匍匐；其柔性與克制，將作品的情思向內收斂，並閉鎖在一圈又一圈的線條迴路裡，不得其門而出。在後者，縱橫筆直的格線，與女子彎曲柔韌的身段恰成對比，兩種幾何語言就在窄長的紙幅上相遇，呈現兩套各行其是、而又交織不悖的造型秩序。

線條是顯性秩序，而結構是隱性秩序：二者不必呼應、但也未必互斥。結構有時則建立在諸元素的整體鋪排上，但也往往有賴線條的牽引與支撐。以《林中馬》為例，森列的樹木在縱向拉出頎長視感，馬隻分布呈水平排開，修長馬頸又提供一道斜出的延展力量。畫家以各軸向的平衡，中和紙紋造就的細碎動感，綜合經營成一派寧靜氛圍。

《親子之愛》則以「圓」為主視覺，打底的色團如是，瓢蟲的圓身圓點亦如是。近放射狀的網線，有效凝聚視線、增加開展於母瓢蟲身上的戲劇張力；造型上雖為直線條，仍隸屬圓形幾何語彙的一環。另有數條線段，無法被收編於圓形系統內。它們肆意橫行，與其說是破壞了基底秩序，毋寧說是在基底秩序上另闢一套任人想像、不能為圖幅所包的宏大陷阱，使視覺趣味不至在「內聚」與「打轉」中太快消亡。

《真空妙有》中，畫家主要採色塊切割繪法，在抽象之中尤重色面接壤的立體感：這與《老人與貓》等景物實在，卻刻意抹去立體感的畫作形成鮮明對比。我們在本作中，不只注意到輕重色彩的比配，更應留心畫家如何將一般片狀的鏡面「腔室化」，表現稜鏡自身的空間感；又藉由這種空間感，呈現整體畫面中間外凸、兩翼隔絕的三維格局。

《慟》在強烈的情緒張力下，亦具紮實的結構性。以三條縱線為經，畫面大致呈左中右三分，那些狹長而緊緊毗鄰的臉，形成如同橫斷山脈般的走勢。又五官與割線的巧設，在正側之間分化出額外的臉，畫面在橫向上益顯險隘。但在縱向上，臉龐拉長的結果使之看來空曠疏寂，以至蒼涼。縱橫、疏密、弛緊的交叉操作，逼仄出一份近於鋒利的哀傷。

（三）色彩

歷史上很長一段時間，人類埋首於對「真實」的探索，形而上與形而下皆然。而「光」在藝術領域中，曾一度是人們寄予厚望的真實——在對色彩的思維中、在科學對光學原理的破譯中，藝術家們因掌握了光與色的奧妙而欣喜若狂。這種發現、以及繼起的嘗試，以印象派的出現為其高峰。 然而，野獸派畫家杜菲(Raoul Dufy)[8]的「色彩—光線理論(Couleur-Lumière)」，也許最能闡明那十九世紀末的新興藝術思潮：「色彩捕捉光線，形

成一個整體，並賦之生命。」他調動了光與色的主從地位，讓色彩去製造光線，而非反之，故將調色盤從對自然的摹擬中解放。

畫家面對顏色，有時顯露與面對線條相似的叛逆——大膽使用原色、淬煉稚樸不拘的線條，這些以張力為訴求的創作傾向，深受野獸派美學陶染。這一類作品，以其高彩度、豐富的色彩組成攫人目光，首推《老人與貓》與《不動明王》二作。《老人與貓》以大筆平塗，不設陰影，正合杜菲對「藝術家創造光源」的反動精神。但看似狂亂的設色，並非沒有章法可循：紅藍二色的互補，似乎象徵老人與貓的精神互補、殘缺重圓；而本該典麗亮眼的紅裝，在膚色的明度正襯下驟然黯淡，隱隱哀輓著美麗事物的折舊宿命。《不動明王》則是諸作中裝飾性最高者，特寫明王半面臉譜，飽滿、勻稱且高彩度的選色，饒富民俗風情。當天南地北的高純度用色同時呈覽於目，大是一番飫甘饜肥的快意。

彩度稍次、色彩組成同樣紛繁的作品，如《真空妙有》、《三叉路》等，因設色繁而虛的特質，往往帶出一種大千幻有的辯證意味。試藉一樁對比來彰顯這類作品的特色：以《情定威尼斯》為例，此畫設色疏、留白多，但因以彩度稍高的紅藍對比色為主調，色彩組成相對單純，加上筆觸零細、疊色硬朗，遂無前述作品帶來的迷離幻成之感，而更像是一座明快鮮活、觸手可及的人間伊甸。

另一類作品呈二元設色，如《豹王》採黑橘、《情竇初開》擇綠橘、《動靜之間》則用黃紫。三件作品中，二色的作用卻大不相同：在《豹王》，黑色用於凸顯主角、對襯火光；在《情竇初開》，色彩發揮暗示及點題的意象性功能；到了《動靜之間》，超現實的浪漫設色用於建構布景、鋪墊氛圍，水平色面盡顯恢闊大氣。

尚有一類作品，其色彩組成相對單一，以青藍色系為大宗。這固然包含本於五彩紙原色創作的《沉睡的巨人》、《嚴母的教誨》等系列作品，亦有《藍馬》、《月河》等作。在此交互參看下，我們更能體會明度、彩度、飽和度各異的藍，落實於五花八門、天南地北的題材時，能幻化出多少同中之異、異中之同。

畫家從不諱言莫迪里亞尼對自己的影響。後者柔美、素雅的用色下湧動的真摯溫度，與克制的線條、簡約的背景形成一份「冷眼熱腸」的對比。底色、衣著或可晦暗，或可寡淡，但膚色恆是紅暈微透的暖色，猶如血肉之軀下生命尊嚴的「葆光」。在《情竇初開》、《憂愁》等人像畫中，我們尤能看見作者對人物臉容、兩頰的膚色如何措意有加，莫迪里亞尼的影響在此不可忽視。

8 拉烏爾·杜菲（Raoul Dufy，1877年6月4日－1953年3月23日），法國畫家，早期作品受印象派、立體主義影響，後期則以野獸派風格聞名。

對於色彩，孟克曾如此評論：「有些色彩與其它色彩和解，有些則相沖。」藝術家的天職，便是扮演色彩的調停者，在相沖中為之尋索和解之道。用色大膽未必即是長處，但用色拘謹必然錯失可能。畫家以敏銳的色彩直覺，大膽探索色彩組合的諸般可能性，故能掙脫保守配色美學的窠臼，真正地做到「育萬物於方寸中，不相肖而各成形色」。

（四）材質

畫家自述創作歷程，常以「茫茫然」、「偶然」、「豁然而通」等詞語，描述一系列思路周折。首先，是一顆「空故納萬境」的無住之心與紙張相照，此即胸無成竹的「茫茫然」階段。接著，或由特殊用紙的紙紋及紙色勾動聯想，或以信筆抹畫觸發繆思，畫家來到「偶然」發酵之階。我們可以看到，媒材在此際扮演要角：筆刷、顏料、紙張的稟賦，都決定了偶然的樣貌，如同每一片入火灼烤的龜甲，在嗶啵聲燒出迥異的裂痕，同時捎來獨一無二的神諭。

也因為如此，畫家熱衷複合媒材及特殊用料手法的實驗。《親子之愛》中，塑膠繩撕去留下的白條創造了偶然，「撕痕」的筆直、以及由是而生的簡潔力感，是人力所難信手而就。《綠女人》中，則先潑灑綠色顏料，讓力場作用織就網狀流路。這些「意向之內、意料之外」的「偶然」，成為畫家進一步創作的基礎，可說是一種「形在意先」取象過程。而靈鞭所指，心門洞開：成竹入胸，即是「豁然而通」的開始。

我們已略窺畫家對各式媒材的來者不拒。就顏料來說，水彩、壓克力、蠟筆乃至中國墨，經常在畫家作品中複合地共舞。如《搶鏡頭》便是以水墨畫為基底，復敷以廣告顏料：水墨暈染的潮濕感，與所繪的沙漠景觀，共譜形式與內容間的矛盾火花。但這種福至心靈的隨興背後，還不時流漏一份人賤之若秕糠、我愛之如珠玉的反骨──選紙尤然。畫家用紙極為廣泛，宣紙、瓦楞紙、水彩紙、或手工紙皆是創作載體。埔里廣興紙寮的「五彩紙」與「雲龍紙」更是近年創作常用的紙材，造紙原料本是雜取樹皮廢料、佐以楮樹皮漿或雁樹皮漿，加入染料染色，並用竹簾盪料入簾、採紗簾分隔紙張、經壓榨後烘乾，再製而成的花紙，造紙技法取中西造紙技術精要，成就令人驚艷紙張特質。一來纖維粗硬，二來本具色彩，多少被藝術家視為一種創造力的喪權。但畫家並不以此為忌，五彩紙獨特的色彩、紋路、深淺層次，反而成為畫家的協作夥伴，在紙張色團、色紋中浮想形象，如待天啟。五彩紙那雲蒸霞蔚般渾沌、滾動、流淌的染色效果，在作家的青色系列中，自證它巧奪天工的玄祕美感。於模擬斑駁感、歷史感一道，尤如羚羊掛角，無迹可求。紙張並不是呆若木雞、逆來順受的載體。不論是本身式樣，或在吸水性、顯色度等屬性上，均與施加的筆觸、色料互為羈絆，考驗著畫家對材料的熟識、品味、及應用智慧。

下筆之前，媒材的選用或許高度隨機。但一旦下筆，油墨舐上紙張纖維，媒材開始揭露自身，畫家便被捲入材料的稟賦之中，一面寸寸推敲著最大化其美學價值的可能。畫家與材料的對話，不是一句先決的祈使號令或鐵口直斷，而是一段共時展開的促膝長談，一切行動均以對材料的尊重為基礎。直到畫作完成的那一刻，材料們將以之卒獲解放的千姿百態，印證福西永的那句箴言：「藝術的材料是不可互換的。」

（五）結語

本章對作品作了兩次權宜性的析離：一是形與意的析離，二是線條與結構、色彩、及材質等綜合要素的析離。落筆之際，即是上述所有要素的同時交纏、同時作用。筆觸的粗細輕重可大幅左右色塊觀感；紙幅尺寸、長寬比影響著畫家如何規畫結構；用的是水彩抑或粉彩，也與線條型態息息相關。要素之間千絲萬縷的互涉，固非本文所能一一包羅。然而，架構愈簡，畫家繪畫風格之繁益彰。當我們析離要素，分門而觀，便可見畫家從不墨守單一策略。他博觀遍取的嗜習，及中西繪畫素養在他身上的交匯，皆是滋養來源。

藉由形式分析，可考察其中名家遺響；藉考察名家遺響，又可檢視畫家如何從中脫胎。我們在《憂愁》中拾得莫迪里安尼畫中女性常有的、介於失神與深思之間的典型情態，以及那在闃寂中遞升的生命尊嚴；但莫迪式的沉著色彩褪去，畫家重新妝以明媚暖色。在《動靜之間》，我們看見常玉[9]筆下一系列動物畫中、曠野與孤獸拉開的空間詩境；新元素「象群」的加入卻改寫了圖畫氣象，兩隻白豹的慵散昇華為帝王風度。而當《慟》作照目，赫然是鮮明的立體派手筆；畫作的深沉悲感，卻讓立體主義所玩轉的線面切割、視角轉換等技法，飽浸了精神向度的象徵意義。模仿與嗣承本是所有藝術家必經之路，但未必所有人皆能做到突變與破立。畫家的可貴，正在敏於模仿之餘，復能以「獨抒性靈、不拘格套」的品味居中調和，翻出新鮮藝象。

9 常玉（1901 年 10 月 14 日－1966 年 8 月 12 日），著名法國華裔畫家，本名常有書。畫風中西融合，常被稱為「東方馬諦斯」。女性、花卉、動物為其作品中最多見的三個題材。

二、意

　　「形」之巡禮已畢，本章繼而進入「意」的詮釋。然行文至此已有兩道規範難題——一為「意」的界說，二為「詮釋」的任意性。故首節先提出圖像與象徵分析，透過觀摩圖像學派典如何解決前述難題，找到詮意的突破口。次則帶入潛意識、精神分析，備為另一套詮釋資源。最後以「表現」強調畫家不重「重現」的繪畫取向，總攝其形意結合模式。

（一）圖像分析

　　在第一章中，我們已對「形」作出通觀與細讀，但圖像學並不以「形」為可資認識圖像的手段。認識與解釋視覺藝術中的種種「象徵」，是由來已久的藝術史工作，也是「圖像學」建立為一門正式學問的學科任務。「象徵」一詞的定義眾說紛紜、寬嚴各殊，然要歸一義：象徵是承載意義的圖像。此意義非透過指涉而抵達，否則淪為符號；此意義也必然不在場，否則淪為再現。畫家的設象與文化涵養、心理作用均高度相關，詮畫遂成為一段鑽進文史肌理、或潛入作家心靈的探賾索隱之旅。

　　現代圖像學由潘諾夫斯基 (Erwin Panofsky)[10] 一手立堂起構，明確擘畫圖像解釋的三層次：第一層次為「前圖像學描述」，即建立在經驗上，對畫中諸現象層事物的指辨。這些指辨的對象又可分為「事實主題」及「表現主題」；前者為物理上的實存，後者則為對抽象情緒、情感的感知。第二層次為「圖像學分析」，是對畫中傳統主題的識別，如文化、宗教、歷史本事。此步驟仰賴大量的文獻與考古知識之旁徵博引、交互參驗。第三層次為「圖像解釋學解釋」，以「綜合直覺」統攝心靈稟賦及世界觀，作為象徵詮義的最終校準。

　　據此，我們得出「描述—分析—解釋」三步驟綱領，從正確認識作品表觀、次表觀元素，連結相關文化母題及淵源，終至以心靈直覺、以對世界的認識統合作品、時空、文化及藝術家，以期對作品的思想內涵、人文意義作出適當詮釋。這是一套同時訴諸自律與他律的分析方法，用意在約束詮釋自由的無際擴張，建立一套客觀的闡釋模型。但我們也看到潘氏理論可能走上的危路——乞靈書卷、對背景資料的過度依賴，卒令研究者離作品本身彌遠。在他之後，奧地利藝術史學家貢布里希(Ernst Hans Gombrich)[11] 進一步校正潘氏圖像學的分析效力，強調「情境邏輯」的重要性，也就是徵驗於藝術家創作時

10 歐文・潘諾夫斯基（Erwin Panofsky，1892 年 3 月 30 日－ 1968 年 3 月 14 日），德國猶太藝術史學家，學術生涯多在美度過。對現代圖像學研究有卓著貢獻。

11 恩斯特・貢布里希（Ernst Hans Gombrich，1909 年 3 月 30 日－ 2001 年 11 月 3 日），英國藝術史學家與藝術理論家。他以文藝復興藝術及知覺心理學為學術主力，同時積極對大眾進行文史、藝術科普。

地背景，思忖創作目的與手段的一致性。要而言之，詮釋終須回歸社會慣例，看重畫家的創作意圖與文化視閾，務使詮釋契合於作品的誕生脈絡。

對恰好處於畫家創作之「當時當地」的我們而言，本具備了詮解位置的優勢。但也正因如此，圖像學所自豪的考據工作失卻用武之地；這也是為什麼，其獨到之處，在當代作品的研究上總較難顯發。本章仍試引入圖像學，意在透過一種更有典則、更有所本的態度，探索畫家作品中可能的象徵。固不能宣稱這些說法即為正觀，但至少，正如貢布里希所言，我們都在盡一位「觀看者的本分（beholder's share）」[12]。

象徵有賴共同認知而成立。在文學與戲劇中，作者可以用時間和篇幅去編織一張暫存的文化網絡，讀者與觀眾遂從中汲取共同認知；因此，文學家與劇作家往往享有自鑄象徵的較大自由。但繪畫恆是已蓋棺的呈現，故繪畫中的象徵，若非透過系列畫作交映成輝，便需以文化或歷史為共同基礎。欲考察畫家托意於象的意向及策略，不能不先具此意識。

「動物」是各文化中均常見的通俗象徵。畫家的《豹王》、《狼性》二作，即援大眾認知中二獸的凌厲形象，為自我精神具現之象徵。前者是熾熱的、行動的，後者則是冷冽的、靜定的，互補、共構為畫家進攻與守備的兩種人格風範。《動靜之間》中，畫家獨鍾的「豹」再次出現，此次卻是一派氣定神閒。此豹與彼豹間，「王者特質」的象徵相去不遠，著重傳達的面相實已游移。再看《青春舞曲》中那隻昂首振翅的彩鳥，我們能當即從傳統意象中提取「鳥類」與「春」的關聯，兼之畫題《青春舞曲》與同名歌謠的互文，這枚「青春」象徵的建構幾乎無意自隱。同樣象徵青春的還有「青草」。畫家在《情竇初開》中將女子長髮著綠，與背景中的綠草相映，可說是一記經過偽裝、卻也飽含提示的象徵，少女與青草如是統合為一首青春的詠嘆調。

作為人類的共同記憶的歷史，也經常是象徵繁衍的溫床。觀《孫中山》一畫，當畫家選用的是「孫中山」這枚極具代表性的歷史、國族符號，我們勢必當警醒於其本具所指的加入，能讓圖畫先備怎樣的意涵。本畫作的中山戴軍帽，著軍服，赫然不是習見的文像，而係武像；對文武形象的文化觀感，就成為有用的圖像詮釋資源。身後國旗在等同國格的同時，「青天白日滿地紅」的設計又本有其象徵意義；唯當我們把自由之藍、博愛之紅放進畫中咀嚼，才能嚼味出畫家為孫文與群姝設色的諷刺性。此外，元素的相對位置與它們的象徵義，也必須被共時處理。舉例而言，如果我們沒有留意到國旗如何掩映後方女子的臉容，我們便無法抖落國旗之為國旗的認知，進而認知到它首先是一塊布，故能有蓋頭、手絹、簾幔等種種同質異形的可能──吾人對物體的界定往往依其功能而生，而非反之。

12 「觀看者的參與（beholder's involvement）」之概念最早由奧地利藝術史學家李格爾（Alois Riegl）提出，強調藝術不能沒有觀看者的知覺與情感參與。此概念後由其學生貢布里希等人發揚，並改稱為「觀看者的本分（beholder's share）」。

相較於具體物件象徵的直觀性，織入畫作形式的造型象徵就要隱晦得多。《勾勾纏》中迂曲盤旋的線條，在隱喻及象徵層次上至少即有三重內涵。其一，「不絕如『縷』」一語已揭櫫這個由來已久的譬類，即所欲象徵之物的相續不斷。其二，線的作用在捆綁，此一概念放入畫中男女關係的語境，可立即聯繫至傳統上象徵姻緣的「紅線」；唯在「紅喜白喪」的中國色彩傳統中，我們不能不以哀代樂地對此「捆綁」作出意義抽換（縱然亦不能豁免於配色美學考量的立場）。其三，當我們進而向古典詩學乞靈，「絲」之象「思」已成傳統，用例不勝枚舉，「燕草碧如絲」、「春蠶到死絲方盡」、「心似雙絲網」等悉可資證。經此爬梳，我們始不至與畫作的造型語言擦肩而過。

神祇形象在被發明之時，往往便賅備象徵意味；作為象徵義的概念，正是其形象的創制所本。不動明王的火焰光背象徵「摧滅罪障，焚燒穢垢」，畫家在畫作《不動明王》中依樣繪呈，但卻用兼為鼻子和男性生殖器造型的紅色色塊，賦予了火焰「慾望」的象徵新義。由此可見，象徵並非一成不變，而可在文化共識首肯的範圍內，被畫家巧妙嫁接、操盤乃至重塑。

以上諸例，帶我們看到不同層次象徵的構接，而圖像學在此間扮演的角色也十足明朗：一道連接作品與藝術家真實生活的人文世界、讓圖像的「不言之教」卒能為人所聞的橋樑。

（二）夢幻／潛意識

對單一畫作的理解，不只在藝術家間的比較框架下浮現，更在畫家自身作品間的對照中清晰。畫家之作可粗分數類，彼此互有交集，並非截然切割：故事性極強者一，如《紅盒子》、《親子之愛》等；情緒性極強者二，《慟》、《藍眼淚》等屬之；風格性極強者三，《卓別林》等青色系列即然。它們各自指向敘事、抒情、技法媒材三個不同側重面向。除此之外，復有一群作品，它們難以自圓為一段敘事、情感寡淡內斂、亦未必有太外顯的風格、技法實踐企圖；但在造境上，它們均帶有一份介乎幻實之間、幽靜杳遠的質感，並不強烈地出離於現實，卻帶有「離俗他方」的彼岸意境。

幾幅以馬為主角的作品，如《三叉路》、《林中馬》、《藍馬》等均有此傾向。畫家的大部分畫作，以一、二少量物象為主角，將之近於居中或滿屏呈現，且以正面示眾為多。在上述三幅畫中，主角則以「群落」型態出現，且無一例外地五官闕如。構圖布物上，一則拉遠視野，營造空間距離；二則讓主角背對或側對觀者，製造心理距離。它們的共同點，蓋在於「象」本身的面貌含糊，姿態中更有程度不一的屈避或掩藏。「象」既不明，「意」亦難白。面對這種若有似無的意象創作，及其所留下的、畫家也無法闡明的解讀空缺，佛洛伊德（Sigmund Freud）[13] 的精神分析及其衍生學說，庶可提供一種索隱進路。

十九世紀中，佛洛伊德的橫空出世，為十九世紀下半葉以降的哲學、文學、藝術、社會學等眾領域帶來驚天動地之變。就藝術創造而論，佛洛伊德主張社會所不能容的「欲力(Libido)[14]」，經「昇華(sublimation)[15]」作用轉化為繪畫、音樂等各種創造力活動；故解讀一幅畫，實際上即是對畫家潛意識欲望的尋索與發微。我們未必要恪守素樸傳統的佛氏舊說。新佛洛伊德學說[16]淡化佛洛伊德對生物性、潛意識的過度強調，調升對社會文化因素的重視，更能幫助我們看清畫家作品中多元勢能的角力。

回到上述的三幅馬畫，《林中馬》中，畫作左邊四匹馬面向一致，右邊一馬獨如異數；且馬群不僅背對觀者，彼我之間更障著牢檻般的樹木。或如《三叉路》，三人三騎無法調和的去向，鎖成一個沒有出路的環。這些意象，可能是畫家看待群己關係的一種心靈側寫。在《藍馬》，馬群雖然姿態各異、似無交集，卻聯結為一種更安定、更和諧的集合態。一旦把握住「群體」這條主軸，帶入新佛洛伊德學者阿德勒(Alfred Adler)[17]的「社會興趣說」等群己理論，我們似能洞悉畫家反映在畫作中、那獨體面對群體之際將迎還拒的複雜情結。

另一項佛洛伊德學說的影響，在超現實主義的興起。當藝術家試圖向內探賾原始情感、意識，在觸底之際，只消再一步的進探，便可能下鑿至潛意識層，以求究竟的自我披露。潛意識帶領藝術家踏上現實經驗的彼岸，擁抱荒誕與無序，直接催生了超現實主義中眾多不可解的噢謎。畫家的《馬—超現實》，畫馬頭上堆石堆的荒謬組合，便是一次毫不諱言的超現實嘗試。

欲論超現實主義，方法及過程永遠重於結果。超現實先驅布勒東(André Breton)[18]嘗於《超現實主義宣言》中下此定義：「超現實主義，陽性名詞，純自動的創作，在這種自動創作中，人們或用語言或用其他方式，表達思想的真實運動。」[19] 自此，自動技法為超現實創作下了重要指導棋，要求藝術家絕對服膺於思想潛流的「任意」

13 西格蒙德・佛洛伊德（Sigmund Freud，1856年5月6日－1939年9月23日），奧地利心理學家、精神分析學家、哲學家。精神分析學的創始人，被稱為「維也納第一精神分析學派」，對後續的社會、文學、藝術各領域思潮有重大影響。

14 佛洛伊德認為本能是身體內部的興奮狀態，而將本能的欲念、本能動機的來源或力量稱為欲力（早年譯為力必多）。

15 佛洛伊德提出的心理防衛機制之一。指人將欲力轉化為社會可接受的形式，如藝術創造或智性工作。

16 新佛洛伊德學說指對佛洛伊德學說作部分修正，不強調性與攻擊衝動，而重視社會文化經驗對人格的影響。仍源於佛洛伊德之理論，故有此稱。

17 阿爾弗雷德・阿德勒（Alfred Adler，1870年2月7日－1937年5月28日），奧地利醫生、心理治療師、以及個體心理學派創始人。為人本主義心理學的先驅、現代自我心理學之父，對後來西方心理學的發展具有重要意義。

18 安德烈・布勒東（Andrē Breton，1896年2月19日－1966年9月28日），法國作家及詩人，為超現實主義創始人。

19 1924年，布勒東與活躍在巴黎的達達主義藝術家阿爾普（Hans Arp）和恩斯特（Max Ernst），聯合發表《超現實主義宣言》（Manifeste du surrēalisme）。受精神分析學派與達達主義（Dadaism）所啟發，他們的作品結合前者對於潛意識的分析、後者對於現狀不滿的叛逆與諷刺。其影響從文學界及於繪畫、攝影和劇場藝術。

與「偶然」，「反理性」及「反意識」即與之等價的正話反說。

我們若回顧畫家「茫茫然─偶然─豁然而通」的創作方法，或許能在其中窺見一些與自動性技法肖似之處。當然，肖似終非實然：畫家放任的對象是媒材，放任的限度，則至乎情感中樞與美學直覺接手而止。超現實主義的難處正在於此：我們永遠清算不清，一道筆觸背後，有幾分潛意識的驅動，幾分美感習性的制約。

（三）表現

畫家作品中，各家風骨俯拾可得，有些甚至毫不避諱地追效前人：如《黑美人》的原型無疑為莫迪里亞尼《斜倚的大裸女》，《吶喊》則直接重製孟克名畫《吶喊》。但他並不瑟縮在前輩陰影中依樣畫葫蘆，其摹擬乃是「奪胎換骨」式的仿作。我們固可視為一種私淑、一種練習，卻不能無見他敢於重煉經典的「膽識」。

對孟克、莫迪里安尼、常玉等人的欽慕並非偶然。從「故事」、「意念」為尚的創作信念，到大膽扭曲的造型、往往離真入幻的設色，表現主義精神在畫家的創作中烙印足深。畫家取消單點透視、削弱體積感、簡化造型線條、並選擇性地敷陳陰影明暗；環境條件、物理法則的掣肘降至最低，人與物的「存在感」遂得以特出。如《嚴母的教誨》一作，初步簡化的立體貓身，其上所接卻是類人的平面貓臉，透過這種不諧、乃至於詭譎感，達致視覺經驗的異化，從而申告：這不是能用一般名物概念隨意掌握的普通的貓。它迫使著你我正視觀看對象的獨一性，而對象的獨一性，又本於情感經驗的獨一性。

換言之，以另一幅作品《憂愁》來說，畫中時有時無、時明確時含混的輪廓線、駁雜帶濁的色色相侵、以及女子的形象與情態，均不是物形、角度與自然光在某一刻的因緣和合，而恰是那姑名之為「憂愁」的情緒本身。《情竇初開》中，樛曲的綠草交織著橙紅天色，乍看幾似一場森林野火；那動盪難平、熾烈到足以燃燒生命，教一整個世界「牢籠芳夢不定」的，無疑是女子精神世界之投射。意在象外，象在言外，固非「情竇初開」四字所能輕輕包羅。表現所以別於再現，即在於它是一種「所見皆所感」的唯心視域。於是，觀者的心靈直覺與共感能力，即是不可或缺、也不能為任何理性分析所埋沒的觀畫工具。

至此，我們能指出，這些五花八門、亂花漸迷眼的作品背後，共享的是畫家對個體生命的愛重。這與畫作的表現性是表裡相依的。作品群以單一人像、動物像居多，縱是說故事的作品亦無宏大敘事，一隻火雞、一位偶師即足以娓娓道來。畫家要構築的不是一個眾生交會、遇合、碰撞並造出一番偉業的場域，那已太像是現實的延伸。他在畫中開闢的是「個體的宇宙」：不論是老藝師在技藝之暮的艱難與堅持、貝多芬與卓別林的

立身姿態、或是豹王生命破繭的瞬間——即如《動靜之間》這樣的作品，也不是萬物睦存的謳歌，而是對豹隻王者精神的禮讚。在他筆下，「個體的聲音」變得格外重要，這個聲音有時即是畫家自己的聲音，從形色之下突圍而出。

（四）結語

當代精神分析師瑪麗恩・米爾納 (Marion Milner)[20] 長期研究藝術、精神與象徵關係，並在其著作中下此斷語：「我可以把藝術家視為正在為情感的生命創造象徵，創造一種方式來使內在生命變得可為人知。」[21] 其象徵論建立在「我／非我」之分的瓦解上，而當她不得不對一些藝術家「模仿自然」的宣稱作出回應，其觀點如下：「我開始懷疑他們是否只在嘗試描述：他們願降服於自己深刻、內在、自發的自然反應，此反應確係來自他們和外界的接觸，並受其刺激而有以然。」[22] 內在不堪蜷縮拳腳，而向外伸展、甚至包吞外物的衝動，即是藝術創作的原動力。依此，凡為藝術，無非象徵。

職是之故，本章從象徵談起，意在先建立細讀藝象的態度及共識。次由潛意識與精神分析切入，進一步探照那些直觀所難及的幽微角落。本文特別標舉《林中馬》、《藍馬》、《三叉路》這組作品，演示如何由把握其題材、造境的對內同調與對外殊異性，指認可能貫穿其中的內在母題，並在精神分析理論的幫助下提出詮釋。最後，復由潛意識的深海汜回淺灘，以「表現」總攝畫家作品中的形意合一，亦藉此申揚：心靈直覺乃是不可替代的意會能力。謹慎如潘諾夫斯基，亦在其方法論第三層次中以「綜合直覺」為詮釋基準，正因沒有人應該、或能夠繞過此天賦，去與一幅畫坦誠相對。

詩無達詁，繪畫亦然。本章援現有理論資源，從不同角度「格畫致知」，未必無枉，但求無縱；只因在一件件傾心力揮灑而就的作品跟前，每一次輕縱與錯失，均是一樁與畫作精魄緣慳一面的憾事。

20 瑪麗恩・米爾納（Marion Milner，1900 年 2 月 1 日－1998 年 5 月 28 日），英國作家和精神分析師，以自由畫、內省日記等精神分析手法聞名。

21 瑪麗恩・米爾納（Marion Milner）著，宋文里譯。《正常人被鎮壓的瘋狂：精神分析，四十四年的探索》。臺北市：聯經出版公司，2016。頁 360。

22 同註 21，頁 222。

結　論

　　畫家習畫年資不長，但憑一份博觀遍涉的好學精神，迅速熟稔媒材與技法、融通各家要旨、並靈活遊戲於所見所學之間。佛典的聖訓「應無所住而生其心」成為其創作心法，畫家並不追求凝鑄出一門風格，以風格即疆界之故。求變之嗜也反映在「不喜如實描摹」上，深信心眼所見方是勝景，是以從線條到用色均逸游自恣，作品表現性尤為突出。此外，廣博的文化陶冶、豐富的生命經驗，成為畫家取之不竭的創作府庫，這體現於其作品的多元題材及繁複思想。文學經典、佛教哲理、傳統偶戲乃至旅遊趣聞，不拘雅俗皆能入畫，是「擊轅之歌，有應風雅」的精神寫照。

　　在作品中同樣一覽無遺者，更有他柔韌堅勁、能屈能伸的人格特質。他不吝披露《藍眼淚》、《慟》這樣的晦暗時刻，卻又能以赤子之心捕捉《搶鏡頭》的詼諧生趣、或者發出《青春舞曲》中對韶華無限美好的禮讚。畫作中「晴時多雲偶陣雨」的豐富情狀，正是生命常態的忠實展現。而畫家在一生風浪中淘洗出能屈能伸的性格韌性，既允許自己悲歌當泣，卻又能轉眼在平凡中拾起趣味，重新生出厚愛人世的熱忱，進而擁抱生命殘缺。這份力量，也許是我們在形色象意中所能讀到的，最動人的語言。

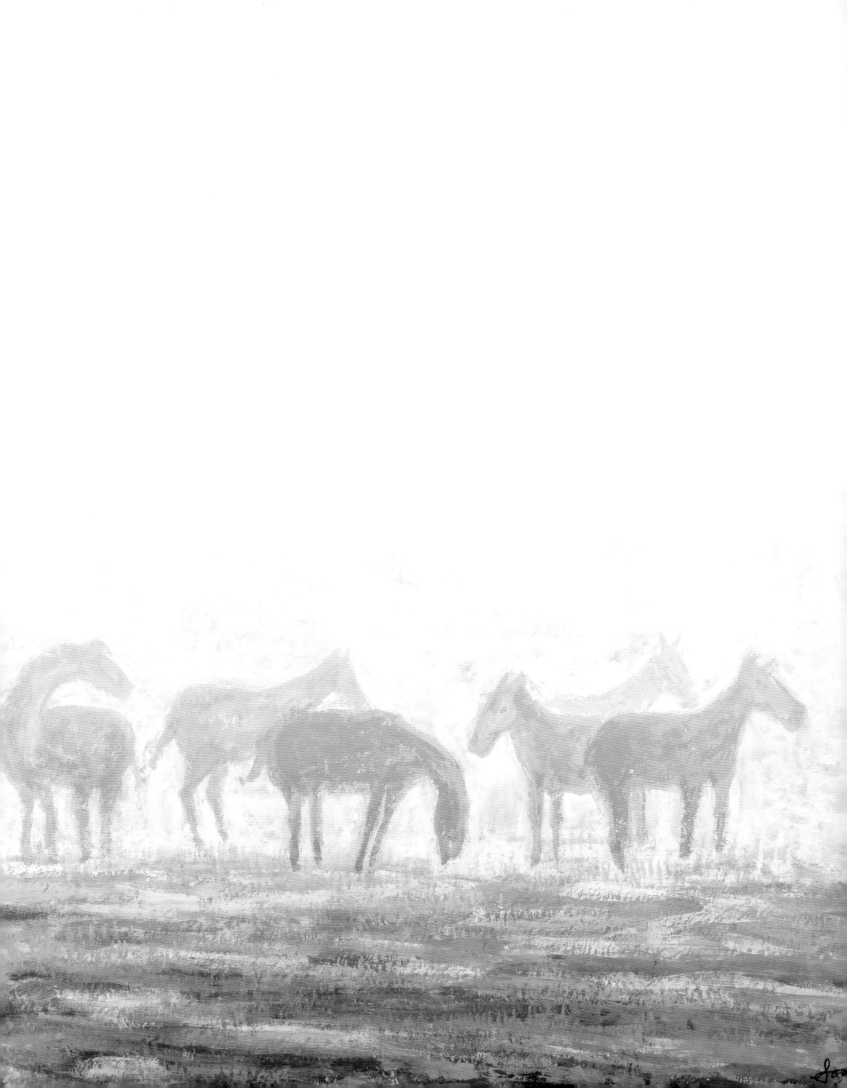

Introduction

Introduction

Antonio Soo, might be far better known as President of Ho Tai Development Co., Ltd. than an artist—or specifically, a painter. He has been productive and fruitful in a variety of fields: on top of the successful business career, his interests include anything involved with genuine blood and flesh, emotions and "beauty." He is an avid reader—no matter how tight his schedule might be, he continues to spend time on reading, and enjoys it. As a Chinese saying goes, he is a man with an "artistically aesthetic mood." But it makes no difference at all whether he is labelled elegant or secular: he is simply himself. He has been interested in, and further devoted to art as he has discovered candid energy of life there. President Soo did not start to paint and draw until the years of 2014, comparatively later than most of those starting an artistic profession. He, however, is culturally literate and keen in making judgement and interpretation. He is not a man constrained by traditional rules and routines. He is characteristic with laisei-faire and independent thinking as well as learning enthusiastically anything new. He thereafter has been able to grasp all art-related ingredients: a good command of the quality of the raw material, full knowledge of schools and styles in painting—which help him to grow style and taste of his own. He in the past five years has been productive in artistic outputs and has greatly enhanced the skills needed in the field. He is without doubt capable of dealing with any kinds of problems and of making good use of the color pens and brushes.

During the short span of time, President Soo has covered a wide range of themes: Chinese vs. foreign as well as ancient vs. modern. The stories hidden behind in the paintings include—but does not limit to: The Journey to the West, Buddhist scriptures, L. van Beethoven's life, Dr. Sun Yat-sen's legends, the wild turkey forgiven rituals performed on the Thanksgiving Day in the U.S.A., and the life of Taiwanese puppet show master Xi-huang Chen. The stories are not turned into paintings in a superficial way; instead, all the paintings reveal true voices of the painter. In "Red Box," we discover a deep exploration of cultural issues; in "Pray of Blessing," we find a socially vigilant eye making fun of playing the hypocrite. As for personal experience

as a theme, there is a painting like "Stealing the Spotlight," an easygoing works filled with fun—only the ones with a naive mind in them can witness a scene that just goes undetected. The sophisticated experience and open-minded thinking as required by an entrepreneur enrich his canvas. He has a sympathy for the people from all walks of life and he never loses his judgement in face of trouble. It is all these views, as are put together, that actually enable him to make elaborate works, which, more often than not, go in sync with what happens in the real life. For methodology, the leaflet refers to a number of research scholars in the fields of history and the theory of arts in the western world such as Henri Focillon, Heinrich Wölfflin, Erwin Panofsky, Sigmund Freud and Ernst H. J. Gombrich to explore and figure out how big-name artists build individual taste of their own and how they make themselves more creative.

I. Forms

In this chapter, we start with formal analysis presented by H. Focillon[1]. We show why forms are absolutely required in art analysis as well as how objective facts manage to progress to a stable state and make a particular art style—an account of the "legitimate source" of forms. The point that H. Focillon insists on: "the first thing of art is forms while the meaning that thus follows up is secondary" is also a base for our layout of the textual series when we place "forms" before meaning. We then analyze forms to be such ingredients as lines, composition, colors and raw materials and put them in different sections for details.

1. Life of Forms

We take, as a concise criterion, a dichotomy of forms and meaning in giving examples of and support to the two contrastive ideas: "visual/material vs. non-visual/conceptual." It is an expedient framework where readers and viewers can quickly grasp the artistic language as is exploited by the painters. We are also altered to the classifying issues in terms of such vocabulary. What, for example, are the "forms" of art? To what contrast are they presented? H. Focillon, a French historian, makes use of poetic languages in his book, Vie des forms. As is implied by the book title, the book gives insightful ideas of what H. Focillon means by "forms." It is more than an academic definition; instead, it is an adequately literate description. What he keeps reminding the readers of is: Artistic works are nothing but forms. It is impossible to separate forms from a complete artistic work; moreover, it is forms that make the whole art work.

We endeavor to extract the style by observing forms. The question, however, remains: what is the real relationship between forms and art style? Certainly, styles are a combination of forms. Forms keep changing indefinitely. Forms settle down as they conform to a set of autonomous and harmonious principles and then they transform to styles. Forms keep updating themselves, though. Styles continue to

1 Henri Focillon (Sep. 7, 1881 ~ Mar. 3, 1943) was a French art historian. He was a professor at the University of Lyon, the Sorbonne and then Yale University in the U. S. A. He was famous for the research of art in the Middle Age.

evolve in the cycle of emerging and disappearing. H. Focillon has been devoted to freeing styles from the external rules and forces like races, environments and time. That said, what do the internal rules of the forms and styles depend on to thrive? On top of the mutual interaction of raw materials, tools and hands, he eventually brings up the concept of "spiritual races:" the individual minds swim through the ocean of time and space with homogeneous needs and discover the family where they fittingly belong. The spiritual freedom, which falls into null all too easily by the imagery of history comes to light again in the pens of H. Focillon.

"The holy mission of raw materials" is another great idea we obtain from H. Focillon. As the principle of forms voices to induce a certain effect, the raw materials that serve the purpose in need pop out accordingly, starting to initiate their life cycle of art. With this, even when H. Focillon has been successful in doing away with the shackles of races, environments and time and in identifying the mental resonance frequency, is it possible for the "holy mission of materials" to rid itself from fatalism? What H. Focillon keeps saying is that the effects that act between forms and materials are virtually bilateral. As the nature of raw materials are implicative and inductive, forms function to urge artists to manipulate and change raw materials. Therefore, we are able to keep a more equivalent viewpoint as we are observing the joint processes between painters and the materials in use.

With the help of H. Focillon's theory of forms, we are able to think twice about the real nature of forms before we begin to make a practical analysis. Truly, H. Focillon discusses the "Life of Forms" in a bigger picture of art history; furthermore, what he alleges in an exquisite and philosophical manner about the essence of forms reminds us of the significance of forms in possession of an autonomous life. H. Focillon thus leads us to enter a world of art where raw materials, skills, masterful minds and hands mix well and at last materials and spirit are harmoniously unified as well.

2. Lines vs. Composition

Heinrich Wölfflin[2], a Swiss art historian, attempts to use the pair of "linear vs. painterly" to describe the shift of art style from the Renaissance to the Baroque eras. Since the late 19th century, modern painting seems on the way to pick up—or rather, highlight—the importance of lines. The movement is closely related to the geometric deconstruction that Paul Cézanne[3] started to initiate. Artists pay a lot of attention to whatever characteristics that lines serve, in addition to the shape-creating functions. Lines are not necessarily considered to be dominant brushstrokes; however, they are a way used to observe the world—in lines, things are enclosed and well-shaped, bringing up closed, definite and individualized entity.

Lines are multifunctional: they draw sketches, stimulate better quality, manage rhythms and guide sights and views. Lines, as they are made smooth or rough, bold or slim, straight or curved, may very possibly evoke mentally-felt difference by association. Those who are skilled with line drawing are able to make use of linear quality: they have great ideas in having works done. Those who are less-experienced only pay attention to the ends of lines, working roughly in between. Taking a closer look at the works, we could say that the lines shown in "Blue Tears" are too restrained since they are far from being free at all. But we also find that the painter was not trapped by the restrain too long, since he learns quickly how to handle the knacks in manipulating pens and brushes and he is successful in figuring out the line style of his own.

Line sketches—shaping the objects with explicit contour lines—are one of the painter's favorite skills, which is best demonstrated in "The Old Man and the Cat" and "Black Beauty." It is a strategy of simplifying things. When the world

2 Heinrich Wölfflin (Jun. 21,1864~Jul. 19, 1945) was a Swiss art historian. In his Principles of Art History, he provides five contrastive pairs of principles in accounting for the art styles in the Renaissance and the Baroque eras. He has a great impact on the formal analysis of arts in the early 20th century.

3 Paul Cézanne (Jan. 19, 1839 ~ Oct. 22, 1906) was a French artist and Post-Impressionist painter. He was endeavored to explore how to simplify objects and make cubic expressions, and thus considered to be a pioneer of Cubism.

is constructed in terms of genuine simplicity and psychological intuition, the painter returns to human being's initial perceptual senses, getting rid of logically sophisticated language and making use of coarse but, at the same time, pure baby-like language. Many world famous painters, like post-impressionist V. van Gogh[4], A. Modigliani[5]—an expressionist from whom the painter has been greatly inspired-- and Fauvist H. Matisse[6], all take advantage of this kind of language to keep a remote touch with their spiritual and imaginary families. Even two paintings with the same theme may tell the painter's preference to, what is called, aestheticization of violence. With the lines being explicit and dominant, the painter brings up his unconstrained nature, trying to develop the previously "bumpy and un-natural" to the full potential their own way. Being smooth seems to be equivalent to being lack of fun, passion and romance which is very likely to occur when the waves crash on the rocks. In "The Scream," –in which all the contour lines retreat—the painter means to rely on the curved lines as is dealt with by E. Munch[7] —in whose paintings, the well-managed and spiral-like force fields are replaced and transformed into geometric units like circles and lines. The painter, on the other hand, does the painting wildly with dry brushes, bringing up a combinational visual effects of being simple and violent at the same time.

In some paintings like "Being Entangled" and "The Woman with Good Serendipity", lines are mainly elements for decoration. The former has streak lines implanted in the work, well-coated with the imagery and the main frame of the painting. The nature of softness and restraint helps the painting converge internally and enclose in a cycle of endless circles. The latter shows a good contrast between straight grid lines and softly charming cures in a female's body. Two geological languages just encounter on the narrow but long paper banner, presenting two sets of

4 Vincent Willem van Gogh (Mar. 30, 1853 ~ Jul. 29, 1890) was a Dutch post-impressionist painter. He was a pioneer of Expressionism. He had a great impact on Fauvism and the Expressionism in Germany.

5 Amedeo Modigliani (Jul. 12, 1884 ~ Jan. 24, 1920) was an Italian painter and sculptor--a representative artist of Expressionism. He is known for portraits and nudes characterized by elegant lines and graceful colors.

6 Henri Émile Benoît Matisse (Dec. 31, 1869 ~ Nov. 3, 1954) was a French artist, sculptor, printmaker and a founder of Fauvism. He was characterized for both his bold use of color and fluid line.

7 Edvard Munch (Dec. 12, 1863 ~ Jan. 23, 1944) was a Norwegian Expressionist painter and printmaker.

shaping orders which go their own way without violating each other by interweaving.

As lines are an explicit order, the frame structure is implicit. These two orders do not attract each other while at the same time, they do not expel each other. In some cases, frameworks are built on the overall setting of the individual elements but there often exists the case where picture structures are drawn and supported by lines. Take "Horses in the Woods," for example. Lines of trees make a lengthened view vertically. Horses spread horizontally whereas the elongated horse necks provide another extended force sideways. The painter creates a directional balance, successfully moderating the comminuted sense of action that comes with flow patterns on paper—and bringing up an overall atmosphere of serenity.

"Love of Parents and the Kid" takes circles to attract sights. The color blocks of the background are circles. The body of ladybugs and the dots on the backs are circles. The radiated grid-like lines attract sights well, adding to the dramatic tension that extends on the female bugs. In spite of the mainly linear modeling, lines, to a certain extent, are an element of the circular family. There exist some sections that do not belong to the same geographic family. They run wildly here and there, the seemingly disruptive orders actually constitute an imaginative "trap" that goes far beyond circles with a hope that the visual fun—that arises between "convergence" and "spinning" would not perish in a short time.

In "Fancy Vacuum," the painter depends chiefly on cutting color blocks, paying, in an abstract framework, a lot of emphasis to the 3-dimensional sense that arises among color blocks. There is a distributional ratio of heavy and light colors. It should be noted in what way the painter organizes "compartments" out of a common pieces-like mirror surface, showing the representation of space that comes with optical prism. The whole structure makes itself a 3-dimensional picture that contains a convex in the middle and an isolation on both wings.

In "In Grief," the painter not only shows a resilient emotional tension but he also develops a sold picture structure. The whole image, with three vertical lines, is approximately divided into three parts: left, middle and right. The lengthened faces which are tightly adjacent to each other run a trend like the cross sections of the

mountain range. An interesting interweave of the five sense organs of the face and the cutting lines are made, by differentiation, into extra faces among the sides, creating a horizontally narrow and steep look. But seen in a precipitous manner, the lengthened faces look empty and lonely—or rather, desolate. The mutually contrastive operations—horizontal vs. vertical, sparse vs. dense and loose vs. tight—enforce an extremely sharp ambience of sadness.

3. Colors

People in every part of the world have long been devoted to exploring what "truth" really means—no matter it comes to metaphysics or anything that is related to earthly objects. In the field of art history, "light" used to be the truth that artists looked forward to: artists—while thinking what colors are and figuring out the principles of light in a scientific way—were ecstatic that they had a good command of the secrets of light and color. The discovery and the further attempts made by later artists and scientists reach the peak as the school of Impressionism appears. R. Dufy, a French Fauvist painter, in his theory of Couleur-Lumière[8], might be the one who gives the best accounts for the newly-fashioned trend in the late 19th century by saying: "Colors catch light, making a new entity with life." Light, for R. Dufy, is not dominant over colors; it is colors that serve to make light, brilliantly freeing the palette from simply the tool of simulation of nature.

The painter, during dealing with colors, seems to be as disobedient as he is with lines—he uses lots of original colors to extract free and easy lines. The creative aptitude this type that focuses on tension is greatly affected by Fauvist aesthetics. Paintings that fall into this category—"The Old Man and Cat" and "Acalanatha" for example--draw attraction in terms of high chroma and a wide range of colors. "The Old Man and Cat" is straight brushed with fat lines without setting any shadows—which conforms to R. Dufy's spirit of anti-convention of "artists being able to create the sources of light." But the seemingly wild setting of colors does not go without orders. The complementarity of red and blue is symbolic to the spiritually mutual

8 Raoul Dufy (Jun. 3, 1877 ~ Mar. 23, 1953) was a French Fauvist painter. His early works were influenced by Cubism.

dependence between the old man and the cat, making the waning moon round again. The red clothes which are supposed to be brilliantly eye-catching abruptly turn out to be dark as is set off by the value of the skin—a symbol of sorrowful fate where even the most beautiful things grow old as time goes. "Acalanatha" is the most decorative painting: a close-up of the Buddha's half face, with a rich, well-balanced and high-saturation selection of colors--a real reflection of folk customs. As a wide range of pure colors are presented on a single piece of work, it is a lot of fun to go through this experience.

It is also possible to make sophisticated works with the colors containing less chroma. Paintings like "Fancy Vacuum" and "The Forked Road," brings up, more often than not, an unpredictably dialectical thinking due to the fact that the complicated setting of colors turn into void. Let us take "Romance in Venice", for example—which is filled with contrast. While the painting is set with light colors and is left with manly blanks, the constitution of colors is relatively simple since the contrastive colors of red and blue, which are high in chroma, make the theme. In addition, there is never any sense of blurred fantasy due to the refined and detailed strokes and the solid color accumulation—on the contrary, it looks more like a bright, lovely and reachable Garden of Eden for viewers.

The painter has another type of works in which a dichotomy of colors is performed. He has black and orange for "The Panther King," green and orange for "The Dawn of Love" and yellow and purple for "Between the Status: Dynamic vs. Static." In these three works, the pair set of colors do not serve the same functions. The color of black, in "The Panther King," highlights the main character and reflects fire. The colors, in "The Dawn of Love," function as an implicational reference to bring out the theme. The romantically surreal design of colors, in "Between the Status: Dynamic vs. Static" are mainly treated to build backgrounds and develop ambience while, the horizontal color plane is symbolic to grandness and magnificence.

There are pieces of works that can be otherwise classified: the constitution is more likely to be of a single color with cyan and blue the most prominent system. In this category, there are a series of works that are based on primary color creation

on multicolored paper such as "Sleeping Giant," "Lessons of the Mother," "Blue Horses," "Moon River" and so on. Taking a cross look at these paintings, we come to better realize how the color blue--with different value, chroma and saturation--can work magic when it is applied to a variety of themes. The tricky use of blue can unexpectedly come up with difference in the commonness, and vice versa.

The painter confesses honestly that he has been greatly influenced by A. Modigliani. What A. Modigliani has done is considered softly beautiful. The lovely and genuine temperature made by plain colors, the moderate lines plus simple background lead to a contrast of "being cold in appearance while hot inside the body." There might be dark or light background colors and clothes but the skins are always of warm color with red faint—like the "dawn" of flesh and blood left to reflect dignity of life. In the portraits like "The Dawn of Love" and "In Sadness," we can see how the painter manages to add his intent to facial expressions and colors of the cheeks—a further example of A. Modigliani's influence.

E. Munch once has a comment on colors, saying that "some colors are in harmony with each other while some others just clash." A mission from the painter is to make himself a moderator of colors, trying to find a more harmonious way for even the colors that crash. It is not necessarily good to use wild colors but artists are sure to lose a good chance if they are too conservative with coloring. The painter has a sharp instinct for colors; in addition, he does his best in exploring all the possible combinations of colors. He is thereafter able to jump off from traditional color matching and to realize the idea of "growing all things in mind and giving particular colors to the inconsistent objects."

4. Raw Materials

The painter usually describes himself to be "at a loss," "only by chance" or "likely to know all of a sudden" in his painting career—a road full of a series of sudden turns in thoughts. First, he simply has an empty heart that does not stick to anything. It is because the heart is empty that there is nothing that cannot be taken into. In addition to a heart of this kind, he has nothing more than paper photography. It's the stage where he finds himself "at a loss." Next, because the paper grains and colors available

for particular purpose stimulate imagination or the brushes at will initiate ideas, the painter come to a stage of fermentation in thinking "only by chance." It is easily seen that intermediate materials play an important role here; that is, the gift for brushes, pigments and paper is a determinant factor for what looks like by chance. Just as pieces of tortoiseshells are burned on fire, at the time when the cracks are formed out of fire with sounds, the unique and heavenly oracle just comes up.

With this, the painter is enthusiastic about finding complex materials and doing experiments that takes special materials and skills. In "Love of Parents and the Kid," the white threads left with the plastic rope having been torn off lead to the creation of "chance." It is tough for human being to attain—especially just in a casual way-- the straightforward "de-epithelization" and the compact power that follows to appear later. In "The Woman with Good Serendipity," green pigments are firstly spread to have the force fields act on the weaving, web-like flow paths. "Chance" of this kind-- "intentional but unexpected" turns out to be a basis for further making. It is a process of capturing physical objects in which "concrete images come up way before he intends to have them in his mind." He starts to become open-minded with the help of these inspirations. As he has the whole picture put into his mind, he becomes "likely to know all of a sudden."

We come to understand that all materials are welcome to the painter. Take pigments, for example. Water paints, acrylic paints, crayons and Chinese inks usually dance in sync with the painter's works. "Stealing the Spotlight" takes ink painting as the background and then apply commercial pigments. The moisty sense caused by the ink painting blooms jointly composes sparks of controversy between forms and contents together with the desert scenes arising. But lying under the inspirational and impromptu tactics is the spirit of disobedience to the convention: "I enjoy taking like a jade whatever chaff people are ashamed of picking up." This attitude is reflected the most in the selection of paper. The multicolored paper, manufactured by Goang Xing Paper Mill at Puli, has achieved notable quality only by processes beyond imagination: A random selection of bark waste, paper mulberry pulp and pigments- -all well mixed—are put into "curtains" for shaking effects. The paper is next sifted out by gauzy curtains, pressed and heated and then it is reproduced into ingrain paper. The combined application of paper manufacturing skills from China and

the western world simply helps to make amazing quality. The paper which contains bold and hard fibers and carries colors of its own is to some extent considered to be a deprivation of creativity by artists. But the painter does not take it as a bogey. The unique colors, grains and distinct layers available to the multicolored paper, to everyone's surprise, turn out to be the best partners, though. The objects that float on the color blocks and grains are just like inspiration from the Heaven. The steamy and cloudy blurs as well as the rolling and flowing dyeing effects—as are utilized in the cyan series--prove to become a mysterious beauty beyond description. The simulation of mottled points and the feeling of passage of time refer to superlative description of art, showing no traces of efforts just like "antelope's sleeping on the tree branch by hanging its horns". Paper as a matter of fact is much more than a passive, non-resistant carrier. Both styles of paper and properties of water absorption and color display are in mutual interaction with the weight of brushes put on or add to the paper and even the quality and quantity of color pigments, proving to be a test for the painter of his familiarity of raw materials, taste and the wisdom.

The selection of media materials might be highly random before artists initiate the first brush. Posterior to that, as inks lick on paper fibers, media materials start a process of revealing themselves and the composers are entangled to the nature of the materials, managing, little by little, to maximize the most possible value of beauty. The dialogues between the painter and the materials in use cannot be executed only by a predominant command; instead, they are a synchronically long talk. Every single movement can be performed only by paying proper respect to the materials. Not until the moment when the painting is finished have the diverse postures been emancipated and made possible by materials—a proof of what H. Focillon insists on the materials of art: they are simply not interchangeable.

5. Chapter Conclusion

In this chapter, we have made two expedient sets of analytical separation: the first is on forms and meaning; the second is on the general elements like lines, picture composition, colors and raw materials. As artists initiate the first brush, all the elements above begin to get interwoven—and interact--with each other. The bold vs. thin and heavy vs. light brushes might have a huge effect on the color blocks. The

size and the ratio of sides of the paper are important factors for artists to frame the picture as a whole in advance. The use of water paints or pastels have a lot to do with the shapes of lines. Big elements required by good painting are too long a list for us to cover in this chapter. The basic idea, however, is: the simpler the framework gets, the more sophisticated painter's styles might become. As we analyze the separate elements respectively, we come to realize that the painter never sticks to a single strategy. The nutrition of painting, for him, comes from his habit of wide range of reading and the convergence of oriental and western features he has learned.

It is possible to have a close inspection on the heritage left from other masters by the analysis of forms. It is more possible to examine how the painter gets reborn higher by looking at the masters' heritage. We pick up the typical moods—a feature found in paintings by A. Modigliani--that occur in the females and between loss of attention and contemplation as well as the dignity of life that comes up abruptly in "In Sadness." By removing Modigliani's heavy colors, the painter again picks up and makes use of the bright and warm colors. In "Between the status: Dynamic vs. Static," we find the poetic atmosphere of wilderness and loneliness available in a series of animal paintings by Y. Chang[9] . The addition of the new element "elephant herd" changes the general view of the painting. Both white panthers, lying lazily over there, are upgraded into king's demeanors. When looking at "In Grief" as a typical photo, we find a distinctive technique of Cubism, which is filled with symbolic meaning in the mental dimension. No artists will become better without imitating or taking from the great, though it is not necessarily true that all the artists can find the way to break through. What we find particular for the painter is that in addition to imitation, he is "able to demonstrate his own characters without being trapped by conventional patterns." He is good at moderating tastes and coming up with brand new aspects of arts.

9 Yu Chang (Oct. 14, 1901~Aug. 12,1966): He was a Chinese-French painter, with the original name of Yushu Chang. He has a mixed painting styles: oriental and western. He is nicknamed as "oriental Matisse." Females, flowers and animals are three themes mostly popular in his works.

II. Meaning

As we finish the trip of "forms," we now go on to interpret what "meaning" is. We are faced with two normal problems: the first is the definition of "meaning" and the second is the arbitrariness of making "interpretation." Therefore, in the first section, we will discuss the topic of analysis of imagery. We will see through the approaches employed by the Iconology School to solve the problems above by discovering a breakthrough to account for "meaning." Then we discuss sub-consciousness and psychoanalysis for another set of interpretative resources. Finally, we discuss "expressiveness," laying an emphasis that painters are inclined not to do "reproduction," and summarizing a model of integrating forms and meaning.

1. Iconic Analysis

In the first chapter, we examine and study the "forms" of art. But the forms do not give adequate information to identify imagery when it comes to iconology. Recognizing and accounting for the "symbols" presented in the visual arts has long been a main task in art history—it is also an important mission to build iconology as a formal research of study. There is no consensus in the definition of symbols, but one thing just goes undoubted: symbols are the imagery that bears meaning. Meaning of this type can't be reached by reference, which falls into signs, if it is. Meaning of this type must not be present, or it turns out to be a mere reproduction. The setting of imagery in the painter's mind is in close relationship with cultural literary and mental effects. The passage of interpreting painting thus becomes an explorative trip into the texture of culture or history and even into the creator's inner heart.

Modern iconology is initially established by Erwin Panofsky[10]. For E. Panofsky, there are three levels in explicitly accounting for imagery or icons:The first level is called pre-iconographical description. The various aspects and objects of painting are correctly identified or referred to on the basis of the viewer's individual experience. The referential objects are then divided into "factual themes" and "expressive

10 Erwin Panofsy (Mar. 30, 1892 ~ Mar. 14, 1968) was a Jewish-German art historian. He spent his academic careers mostly in the U.S. He made great contribution to modern iconology.

themes": the former being a physical existence and the latter being senses to abstract emotions and empathies. The second level is "iconographical analysis," which is to identify the traditional issues in the painting such as culture, religion and historical events. For this step to do things well, we need to rely on a great amount of documents and knowledge of archeology for cross reference. The third level is the "explanation based on iconology." Integrated intuition is required to exercise control over mental talents and world views, acting as the final standards for the interpretation of symbols.

With this, we come up with a three step principle: "description, analysis and interpretation": identifying the external and sub-external elements of the works, linking cultural issues in discussion and finally –with the help of mental intuition- -coming to integrate works, space, culture and artists, hoping to give a proper interpretation to the connotation and human significance of the art works. It is virtually a system that resorts to both autonomous and heteronomous analysis, with an aim to keep unrestrained freedom from endless expansion and to build an objective and illustrative model. We, at the same time, notice that E. Panofsky's theory might be on a risky road—a heavy dependence on big volumes and documents; besides, the relevant background in need might keep the researchers far away from the works themselves. Later, Ernst Hans Gombrich[11] , an Austrian art historian, provides a further revision for the analytic effects in E. Panofsky's iconology, laying stress on the importance of "situational logic." In other words, we have to justify temporal and special backgrounds and to consider whether the artists are consistent with the ends and means in creating works. The point is interpretation of arts needs to go back to social conventions. We need to take a look at artists' intent of art creation and cultural views. The goal is set to make the interpretation congruent with the thread of ideas that gives birth to the works.

We are in a better position to interpret art works since we happen to be "of the same time and place" with the creative painters. But just for the same reason, the

11 Ernst Hans Gombrich (Mar. 30, 1909 ~ Nov. 3, 2001) was a British art historian and theorist. He took the Renaissance art and cognitive psychology as his major academic research. He took efforts in making popular literature, culture, history and art.

textual research of which iconology is proud turns out to be of little use for us. This explains why the painter finds it difficult to earn high praise from the contemporary reviewers and critics. In this chapter, we attempt to introduce iconology, trying to account for the possible symbols in the painter's works by a more organized and more dependable approach. What we do is, of course, still far way from being simply legitimate; however, we are doing our best for a "beholder's share[12]," as is mentioned by E. H. Gombrich.

It is impossible to identify symbols without common cognition. In literature or drama, the authors are entitled to weave a temporary network of culture—where readers and viewers can thus extract common cognition. This is why authors and playwrights are usually given more room to build symbols of their own. Painting, on the other hand, is a different story. It is a representation that "has already been decided." So, the symbols in the paintings call for either a series of paintings for cross reference or shared culture or history as a base. We need to keep the idea in mind before we examine the intension and strategy of entrusting meaning to imagery.

Animals are a symbol commonly seen in different cultures. "The Panther King" and "Wolf Instinct" are two examples that satisfy the general belief that both beasts are vigorously dangerous. Both are symbols of spiritual self-realization. Panthers are passionate and quick in movements while wolves are cold and calm. Mutual complementation and co-construction are two personal characteristics— offensively or defensively. In "Between the Status: Dynamic vs. Static," the panther shows up again—in an easygoing composure this time. The symbol of being a king in this painting is basically the same as the one in another painting, so the ambition to re-deliver the symbols has been shifted. Looking at the colorful bird in "Dance of Youth", with its head raising upright and wings flapping, we are sure to extract the concept from the conventional symbols which is associated with "birds" and "the season of spring." In addition, there is a song with the same title "Dance of Youth,"—

12 The idea of beholder's involvement was introduced by the Austrian art historian Alois Riegl. The phrase denotes that part of an artwork's meaning must be contributed by the viewer's perception and emotion. It was popularized by many other art theorists, including his student Ernst Hans Gombrich, who helped to rename it as "beholder's share."

to make the painting's theme intertextual with the song lyrics, meaning that the symbol of "being young" simply justifies itself. Green grass is, again, a symbol for "youth." The painter in his painting "The Dawn of Love" has the girl's long hair painted green in reflection to the green grass in the background, which can be seen as a symbol that is camouflaged and simultaneously filled with hints. Young girls and green grass here are integrated into an agile piece of aria.

History, as a common memory of people, also breeds symbols. Take the portrait of "Dr. Sun Yat-Sen" for example. As the figure like Dr. Sun Yat-sen—a symbol of great historical and national sinificance—appears in the painting, we must be cautious about the painter's intent: What kind of particular meaning does he want portrait to be with? The figure in the painting is in a military cap and uniforms—obviously not the civilian one commonly seen in public. The cultural feel of civilian vs. military imagery thus becomes a useful resource for proper interpretation. The national flag—which often refers to properties of a country—certainly has a symbolic importance as the flag is such designed as: "A bright sun in the blue sky with the earth surrounded by all reds." It would be out of the question to realize the irony the painter manages to place particular colors to the main character and the females around without knowing that blue has an implication of freedom and red of universal love. Besides, the relative locations of the picture elements in the painting need to be considered, too. For instance, if we are not aware that the flag actually shields the face of the woman standing behind, we are unable to recognize that it is actually a national flag; instead, we might mistake it as a piece of cloth made into hood, handkerchief or curtains—something with the same materials but different shapes. Objects in general are first classified in terms of their functions, but not vice versa.

The symbols of specific objects are easy to tell. In contrast, the modeling symbols that are interweaved into the painting are much tougher to see through. In "Being Entangled," the lines that run in a curved or even distorted way have at least three implicational or symbolic significance. First of all, the idiom "hanging by a thread" reveals itself that the objects that bear that symbol are going on endlessly—though weakly. Secondly, the thread or the rope function to bind. When we adopt the idea of binding and put it to demonstrate the gender relationships in the painting,

we come up with a clear idea that this thread simply links to the "red" one, which customarily a blessed symbol of marriage. Under the Chinese traditional color system, people use red envelopes in wedding but while ones in funerals: thus saying that red refers to happiness while white, sadness. Only in the environments of this kind, we cannot but take "sadness" instead of "happiness" to replace the meaning of "binding"--though we are still not exempt from the consideration of aesthetical color setting. Thirdly, as we refer further to classic poetry, the symbol of "silk" for "missing someone" has always been made true. Quotes are quite many, like: "the green grass in Yan grows like jade-colored silk" (from Bai Li), "spring silkworms never ending to bring out silk until they are dead" (from Shangyin Li), "the heart being like the net weaved by double threads of silk" (from Xian Zhang) and so on. With ideas sorted out this way, we now will not miss what the modeling languages in the paintings really talk about.

Gods in the heaven are usually assigned a symbolic allusion even before their imagery occur to the world. As a matter of fact, the making of the imagery is mostly based on the symbolic concepts attached to them a priori. The back of the Buddha in "Acalanatha" is in flames: a symbol of "exterminating sins and extinguishing dirty things." The painter has the image painted with the original as a model; however, he makes use of red color blocks—in the shape of both nose and the male genital—to enforce the flames with a new symbolic meaning of "desire." It proves that the implications of symbols might change under the cultural consensus, which in turn might be cleverly linked, manipulated and even re-shaped by the painter.

We have, with the help of the examples above, seen a symbolic linkage of different levels. Iconology, clearly, plays an important role in these cases: it functions as a bridge connecting the works and the human world in which the painter lives, enabling the "silent lessons of imagery" to become better-known.

2. Dreams / Sub-consciousness

For a good understanding of a single painting, we can compare it with similar works made by other painters; in addition, we might get a fuller picture if we examine and compare it with other paintings done by the same painter. It might be possible

to classify the works of the painter in question into some categories. They are not clearly-cut but they have something in common. Some paintings belonging to the same category are of a story-oriented, like "Red Box" and "Love Between Parents and the Kid." Some paintings are highly emotional, like "In Grief" and "Blue Tears." The third type of paintings have a strongly particular personal style in them like the cyan series--including "Charlie Chaplin." All three categories of paintings lay—respectively--emphasis to different themes: narrative, emotional as well as technical in terms of intermediate materials. There is still a fourth category: the paintings do not make a complete story of its own, contain little and internal emotions, do not have too many external styles and do not intend to show off ambition. As for the environments set in the background, they unexpectedly have a quality of being between real and imaginative and of being quiet and distant. They are not toughly separated from the earthly world whereas they keep a sentiment of "going-far-from-hometown" to an unfamiliar place.

Some of the paintings featuring horses tend to have this feeling, such as "The Forked Road", "Horses in the Woods" and "Blue Horses." Most of the painter's works have one or two objects as main characters, which are positioned in the center or occupy the full picture, with the faces looking at the viewers. But what we discover in the horse-related paintings, the main characters appear "in herds"—without showing facial organs. For the purpose of constructing the imagery and laying out objects, the painter creates a "pull-away" effect and make a mental distance by having the main characters looking at the viewers the back-face or side-face way. The point in common is the blurring of faces of the imagery, poising to get away with people or to hide themselves from being seen. Due to the "icons" made blurry, the "meaning" become difficult to figure out. In face of these elusive works—and many other interpretive points of vacancy that even the painter himself has no accounts on, the approach of psychoanalysis by S. Freud[13] and the related theories that derive from the school might be a course to step on.

13 Sigmund Freud (May 6, 1856 ~ Sep. 23, 1939): He was an Austrian psychologist, psychoanalyst and philosopher. He was the founder of psychoanalysis, which was regarded as "the first psychoanalysis in Vienna." He had great impact on the philosophical trends in the fields of sociology, literature and art.

The appearance of S. Freud in the 19th century has caused a drastically big change to the fields of philosophy, literature, art and sociology in the second half of the 19th century. As far as creative art is concerned, S. Freud argues that Libido[14] —which society finds hard to endure—transfers to energetic actions required by painting and music in terms of sublimation[15] . This way, an interpretive reading of a painting is equivalent to searching for the subconscious desire that lies in the inner heart of the painter. It should be noted that we do not have to stick to the plain and conventional theory by S. Freud. The renewed principles of Freud School[16] , which have greatly reduced excessive dependence upon biological traits and sub-consciousness, have otherwise enhanced the social and cultural factors and they are of great value to enable us to take a clearer picture of the multi-potential energy underlying in the painter's works.

We now take the three paintings again for further comments. In "Horses in the Woods," the four horses to the left head to the same direction with another singular one to the right. The herds of the horses not only have their backs confronting the viewers, but they are also separated with trees or hedges between each of them. In "The Forked Road," three riders are on different horses while the riders never reach a consensus for the proper direction. They are actually locked as a ring without being able to provide an exit. This imagery might be a reflection of the painter himself, who just can't make a deal between the individual and the group to which he belongs. In "Blue Horses," every single horse poises individually. The seeming lack of similarity turns out— when put and united together—to be a more stable and harmonious collective entity. Once we hold the theme "herds" at hand, and put it into the Alfred Adler's[17] "social

14 Instinct, for Freud, is a state of excitement inside the body. The origin or power of instinctive desire or motivation is said to be Libido.

15 It is a psychologically defensive mechanism by S. Freud. It is a form where Libido is transformed into one acceptable by society, like the work of art creativity and intelligence.

16 It is a revision of Freud's theory. The new theory does not lay much emphasis on impulse of sex and attack; instead, personal traits are more affected by social and cultural experience. What is called "New" is that it has an origin from the "Old" Freud's theory.

17 Alfred Adler (Feb. 7, 1870 ~ May 28, 1937) was an Austrian medical doctor, psychotherapist. He was the founder of the school of Individual Psychology, a pioneer of Humanistic Psychology and he was regarded as Father of Ego-psychology. He had a great impact on the development of psychology in in the western world.

interest" theory—in which he attempts to explain the relationship between a person and the people he deals with in his society, we are in a good position to get insights of the "yes but in a resistant way" complex hidden behind in the painting that simply arises when an individual has to be faced with people around.

S. Freud's psychoanalytical principles have another effect: the rise of surrealism. As artists attempt to seek original emotions and consciousness, they, with one more step of exploration, might dig into the level of sub-consciousness for the complete self-exposure. The sub-consciousness this way leads artists to step on the banks of real experience, enabling them to embrace those of absurdity and lack of orders and to straightly solve many unsolvable puzzles for the surrealism supporters. The painter's "Horses together with surrealism"—the funny combination of horse heads piled with rocks is obviously a surreal experiment.

In surrealism, the approaches and passages always carry more weights than results. A pioneer of surrealism, André Breton[18], in his Surrealist Manifest gives a definition: Surrealism, a masculine noun, a genuine movement of purely automatic creativity in which people either use verbal or non-verbal means to express their thoughts[19]. Automatic drawing since then has a huge influence on surrealist art creation, asking artists to absolutely obey "arbitrariness" and "chance"—which, in other words, are equivalent to "anti-reason" or "anti-consciousness."

Going back to the painter's road to creativity: "at a loss," "only by chance" and finally to "likely to know all of a sudden," somehow we find something in common with automatic drawing. Truly, "something in common" does not equal "something de facto." The objects the painter set free are intermediate materials. The limit of setting free reaches no more than the moment after emotional center and aesthetic

18 André Breton (Feb. 19, 1896 ~ Sep. 28, 1966) was a French author and poet, considered to be the founder of Surrealism.

19 André Breton—together with the Dadaist artists Hans Arp and Max Ernst, who were then active in Paris—jointly published Manifeste du surréalisme in 1924. They were enlightened by the school of psychoanalysis on the analysis of sub-consciousness and Dadaism on rebellion and irony caused by the discontent of circumstances. The book has an impact on literature, painting and drawing, photography and theatre performance.

instinct take over. What makes surrealism tough is: we will never have an accurate account of how many percent of sub-conscious drives and how many percent of conditionings aesthetic habits make lie behind just a brush stroke.

3. Expressiveness

In the painter's works, it is possible to find the traces of his predecessors'. Some of the paintings are obviously the imitation-like copy: the prototype of "Black Beauty" is undoubtedly A. Modigliani's "Reclining Nude" and "The Scream" is straight cloned from Munch's famous painting of the same title. But what he does is more than just make an exact copy of his predecessors' masterpieces shrinking in their shadows. What he does is a "reborn" imitation copy. We can take it as a kind of "paying respect to the masters and taking them as teachers," or personal exercise; however, we cannot ignore his "having guts" to train himself with classical works.

It is no accidental for the painter to adore masters like E. Munch, A. Modigliani and Yu Chang. The painter believes that creation comes from "stories" and "ideas." The expressionism is deeply rooted in his creative mind due to the fact that the modeling is bold and distorted and that the colors are set to make fantasies. He insists that: the single point perspective is removed, the 3-dimensionalness is weakened, the lines are simplified and the shadow shading is selectively prepared. As he tries to hold back the environmental conditions and physical principles to the minimum, the "existence" of people and objects start to emerge. As in "Lessons of the Mother," the preliminarily simplified 3D cat body is given a flat human face, trying to achieve— in terms of incongruity and even eccentricity or wildness--a visual alienation. It is a claim that this is a common cat that cannot be accounted for or get known well by a regular naming. It enforces us to take a vigilant look at the singular uniqueness whereas, by the way, the uniqueness of the objects is rooted in the uniqueness of emotions or experience.

Let us examine, for example, another piece of work, "In Sadness." The contour lines are seemingly visible or invisible and they look clear at some time while they are vague at some other time. The heterogeneous and turbid colors penetrate each other. The image of the woman and her posture are not a fatal encounter by objects, angles and natural light; instead, they are the emotion of being what is called "In Sadness"

itself. In "The Dawn of Love," we might, at the first sight, take as a wild fire the bending green grass interleaved with the orange color of the sky. What is turbulent, scorching hot enough to have life burning, emotional ups and downs in the cage-like house is actually a projection of the woman's spiritual world. The meaning lies outside of the imagery, and vice versa. All these emotions cannot be merely described by the phrase of "The Dawn of Love." Expressive works are different from reproduction because they belong to an idealistically visual range of "what you see is what you feel." This way, the readers or the viewers need to have mental instinct and the ability of being collectively affected—a tool of studying or appreciating paintings that cannot be buried by any reasonable analysis.

We now point out: What is underlying in the paintings—of a diverse variety of topics and sometimes puzzles--is the painter's love of the individual life, which the painter would be delighted to share. Most of the paintings contain a single portrait or animals. Even the paintings that tell stories do not contain long narration. Either a turkey or a puppet master is good enough to deal with the full story. The painter does not feel like constructing a big field domain in which people, animals and events encounter. It is too much like the extension of reality. He manages to develop "a universe of an individual entity: no matter whether it is a master artist's hardship of life and insistence at an old age, the standing postures of van Beethoven or Chaplin, or the moment when Panther King breaks through its life. Even works like "Between the status: Dynamic vs. Static" are never a song in praise of all creatures living in harmony or Panther King's spirit. Under his brushes, "the voice of each and a single individual" becomes of great importance. The voice is sometimes uttered by the painter himself, running out of the obstacles accompanied with imagery and colors.

4. Chapter Conclusion

Marion Milner[20], a modern psychoanalysis researcher, has long been studying the connections among art, spirits and symbols. She once states in her book: "I consider artists to be the ones who work to create symbols for life. They do create

20 Marion Milner (Feb. 1, 1900 ~ May 28, 1998): a British author and psychoanalyst. She was known for her psychoanalytic approaches used in free drawing and painting as well as in introspective journaling.

such a manner that they can use it to have the inner life well-known[21]." This kind of theory of symbols are built when the division of ego vs. non-ego begins to collapse. As she has to respond to the claim that artists "imitate the nature," she illustrates her point: "I am wondering if what they do is just an attempt to describe: they are willing to subject to the profound, internal and autonomous natural response, which comes from the contact with the external world and they do what they do just because they take the stimulus from it[22]." The impulse of being unable to endure the crimpy arms and legs and to extend outward or even devour everything out there is the drive for artistic creativity. That is to say, art is not art any more without symbols.

The chapter, as we have seen above, starts with symbols. We aim to build attitudes and agreements required in reading imagery in art. Then we take sub-consciousness and psychoanalysis into account, exploring the dark corners that are hard to perceive straight through the senses. We also highlight a series of paintings featuring horses: "Horses in the Woods," "Blue Horses" and "The Fork Road." We demonstrate how the painter picks up a subject, models the canvas and—by making inner harmony and external particularity--identifies the possible mother issue that links the details, and gives proper interpretation with the help of psychoanalytical principles. Finally, we swim back from the deep sea of sub-consciousness to the shallow beach and--in terms of "expressiveness" to summarize the integration of imagery and meaning for painters--argues that mental instinct is an irreplaceable ability to "read for meaning." E. Panofsky is cautious enough to take "integrated intuition" as a standard of interpretation in the 3rd level of his principles just because no one is supposed to or able to bypass this gift to honestly face a painting. Admittedly, it is impossible for poetic verses to be identically interpreted and the case applies to the painting, too. We here do our best, from different points of views, to "acquire knowledge by studying painting works" in terms of resorting to the theoretical resources currently available. What we do is not necessarily true; however, we simply would not like to let go of any possible interpretive reading. With a painting at hand that takes so much energy and effort to finish, a single neglect or miss in interpretation—no matter how trivial it is—turns out to a matter of regret if we fail to know the real meaning that underlies behind.

21 A Mandarin version of The Suppressed Madness of Sane Men: Forty-Four Years of Exploring Psychoanalysis, p. 360, translator: Wen-li Song, published by Linking Publishing Company, Taipei, 2016.
22 ibid., p. 222.

Conclusion

The painter does not have a long time studying how to paint. By encouraging himself to study a variety of volumes of different topics, he soon gets accustomed to materials and techniques in need. He is aware of main principles of different schools of art, which he seems to have an easy access to. The precious idea he gets from Buddhism that "people are supposed to grow a clean heart without adhering to routines"--becomes the most important principle as far as artistic creativity is concerned. The painter has no intention to cast out a school in style of his own since he believes style to be boundary. The fact that he keeps changing is also reflected in the attitude of "loathing describing things as they are." He is convinced that mental interpretation is a much more beautiful view than eyes can see; therefore, he finds himself totally free in the use of colors and lines, which in turn makes his works highly expressive. In addition, thanks to the cultural atmosphere he is grown in and the rich experience of life, he seems to have an indefinite resource of ideas to render his creative ideas, which we can see from the collection his works of a wide range of themes and with sophisticated thoughts. Stories from literary classics, ideas from Buddhist scriptures, traditional puppet shows and even funny episodes from a trip—no matter whether they are conventional or secular—make a theme of his paintings, eventually the best example of what is mentioned as: "The songs of beating the yoke while riding a carriage are supposed to be of natural elegance."

The personal traits of being flexible and persevere and knowing when to bend and not can be easily found everywhere in his works. He does not take it anything sorry when he reveals dark moments in "Blue Tears" and "In Grief." He becomes witty and humorous as he makes "Stealing the Spotlight" with an innocent heart of a kid and at the same time, he is willing to praise how grand it is to be young in "Dance of Youth." The rich contents of the stories in the paintings—as changeable as the clouds in the sky—is a faithful representation of life in general. The flexible characters—knowing when to bend or not—which the painter learns to develop through hardships of life allow him to cry when an elegy is playing and next to pick up fun in no time from what is happening daily, giving a rebirth of enthusiastic love of the world and then goes on to embrace the broken pieces of life. This power, once obtained by reading the forms, colors, icons and meaning in the painting, might be the most touching language we have ever learned.

作品導讀

A Guide to Art Works

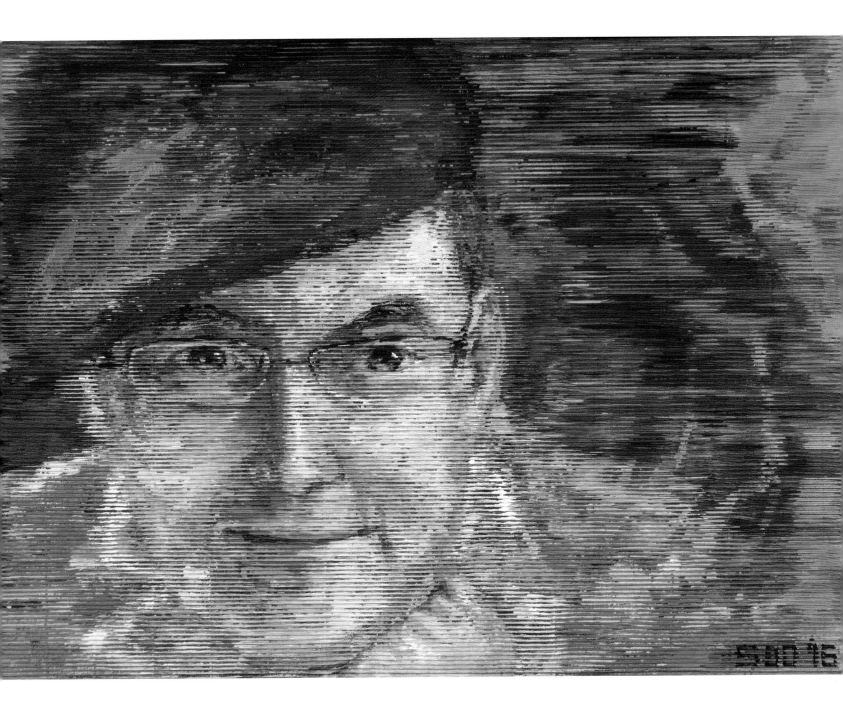

畫家的自畫像 A Self-Portrait by the Painter

瓦楞紙　壓克力顏料
52×78cm
2016

　　畫家素喜探索形形色色的顏料、紙材，以它們各異的秉賦，為新變之靈糧。對「自畫像」這樣自我再現的創作，不能不措意尤加、力圖殊異。「視角影響觀畫」，是畫家在自畫像中亟欲實驗的主題，而瓦楞紙就在這樣的嘗試中雀屏中選。平面紙幅上，非不能搬弄多重角度的視覺戲法；但瓦楞紙紋磕磕絆絆，更容易讓顏料的著落、光影的照射呈現峰谷異趣。

　　碰上流淌不馴的顏料，平行劃一的紙紋就成了引流槽，在橫向上牽引，縱向上截斷。溝壑連綿的瓦楞紙，一來在維度上提供了立體感，二來造成色段、筆觸的錯位與不相續，形成像素化的顯色效果。我們看到紙材在此發揮的奇效──它營造出一股數位感，與畫家繫年、署名所用的數位字體恰恰相稱。人物的邊界參差不確，畫家幾乎像是被投影、播送於螢幕之上；當我們凝視畫家，他亦托腮回望，銜著一抹親和而略帶促狹的笑意，似乎有意挑動觀者虛實之辨的敏感神經。

　　溫暖而飽和的背景中，伏藏著色彩駁雜、但理路齊整的亂流，上演一場有序與失序的拉扯。紙紋是有序的，顏料是無序的。程式是有序的，藝術是無序的。在一個數位影音投放、圖像再現都成本低廉、不費吹灰的時代，畫家用紙筆建構這樣一幀擬數位的畫境，也許正是以自畫像，叩問自畫像在今日的意義，也提醒著所有人：繪畫，及其所牽動的浮想聯翩，本是一種最素樸的虛擬實境。

藍眼淚 Blue Tears

皺紋紙　衛生紙　壓克力顏料　水彩　蠟筆
62×89cm
2017

　　那是馬祖最令人心馳的勝景之一，卻擁有一個叫人心碎的名字──「藍眼淚」。即便畫家從未親臨，也在看見藍眼淚的照片時，絕倒於那幽暗海域裡晃盪的藍光。

　　如果說馬祖藍眼淚是一首靜靜放光的奇幻小調，畫家筆下濃墨重彩的《藍眼淚》，則因為已經內化為畫家的心靈地景，而徹頭徹尾地翻作新聲。馬祖藍眼淚因暗夜藍熒的明暗對比而絕美，畫中的明暗對比卻是如此驚心動魄，在粗重的筆觸、駁雜而不通透的色彩中渾失寧靜。鎏金天色、蒼綠山巒，理應為風景注入生機；但正是這些生機，讓暗影與魑魅有了鯨吞的對象，某種毀滅性力量注滿每一個背光的罅隙，鼓動不休。山、海、天本有無限開展、無限延伸之可能，然而那環伺四合的黑影，由外向內圍困風景、侵蝕肌理，渾是柳宗元筆下「郊環萬山，騰湧波濤」的羈囚心境。「藍眼淚」，似乎誠然從一句浪漫的修辭，成為聲聲絕望的泣訴。

　　畫家喜愛挑戰各式質材，於此更在畫紙敷上衛生紙，創造出沿海岸線蜿蜒的明藍色亮帶。衛生紙攢聚與稀鬆的不勻分布、其纖維與畫紙纖維的相遇，讓作為畫作主角的藍眼淚更增亮點，也牽引出明確的視覺動線。儘管此時期未臻成熟的運筆，讓線條猶帶拘執痕跡，整體色彩經營已鑿出淵深的情感容量。在深藍遠洋、與黝黑陸域的夾擊之間，畫家的悲傷就在那一帶湛藍淚海中翻攪、堆疊、迤於無窮。

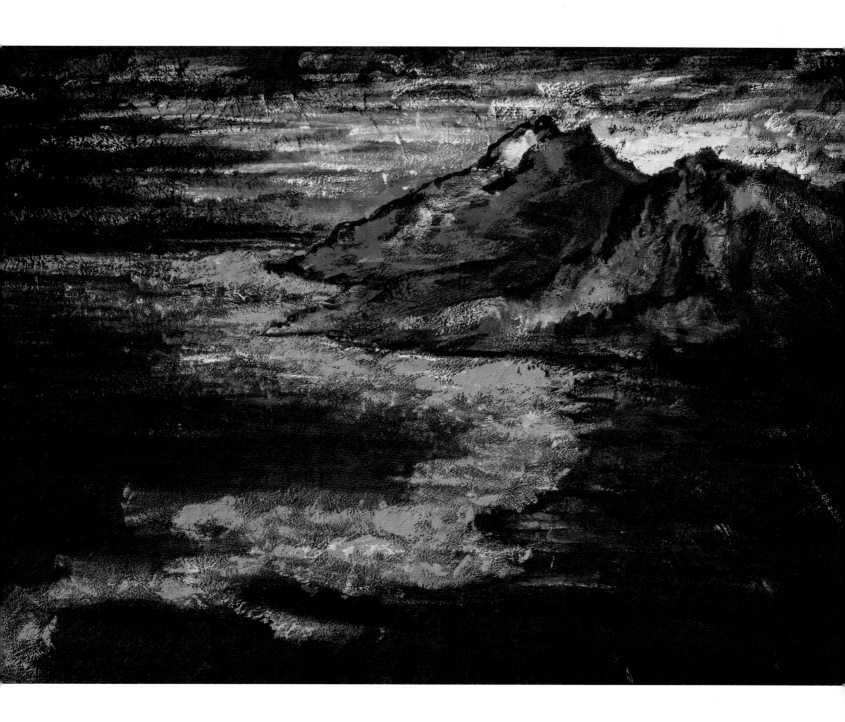

老人與貓 The Old Man and the Cat

廣興紙寮雲龍紙 壓克力顏料
90×62cm
2018

　　從翠玉環到明月璫、珍珠項鍊到繡花旗袍，畫中的女人一襲盛裝，儼然經過悉心妝點。然而，這樣一尊典麗的形象，安放在單調而素樸的背景前，隱約中流露一股百無聊賴、孤芳自賞的孤寂；粗曠交織細膩的線條，勾勒出老人寂寥的雙手，使人能格外敏感地識破、感受到詩詞中的閨怨與遲暮憂感。華服之上，華髮之下，夾在兩個互為反差的意象之間，是女人寫意而不協的五官。兩瞳幽幽，眼尾一沉，觀者不能不嗅出幾分黯然。

　　作為主視覺，馬諦斯式的用彩、濃郁明亮的暖色幾乎只是張幌子。藍，反成為畫面中最溫暖的顏色──右下角一隻藍色小貓，溫溫順順地蹭上前來，帶來陪伴與寬慰；靜定的場景，因之注入一點活潑靈動，紅藍之間「火融冰」的直觀聯想，在此全然翻轉。無論是在色彩上、情緒上、抑或動態感上，小貓的存在，都四兩撥千斤地平衡了畫作基調。

　　是誠有解語花般的通透，抑或只是小貓生性親人？人與動物之間，是否確實存在某種冥契？在老人與貓交會的眼神、交疊的指掌中，這些追問似乎不再重要，因此刻的陪伴，即是無可取代的真實。

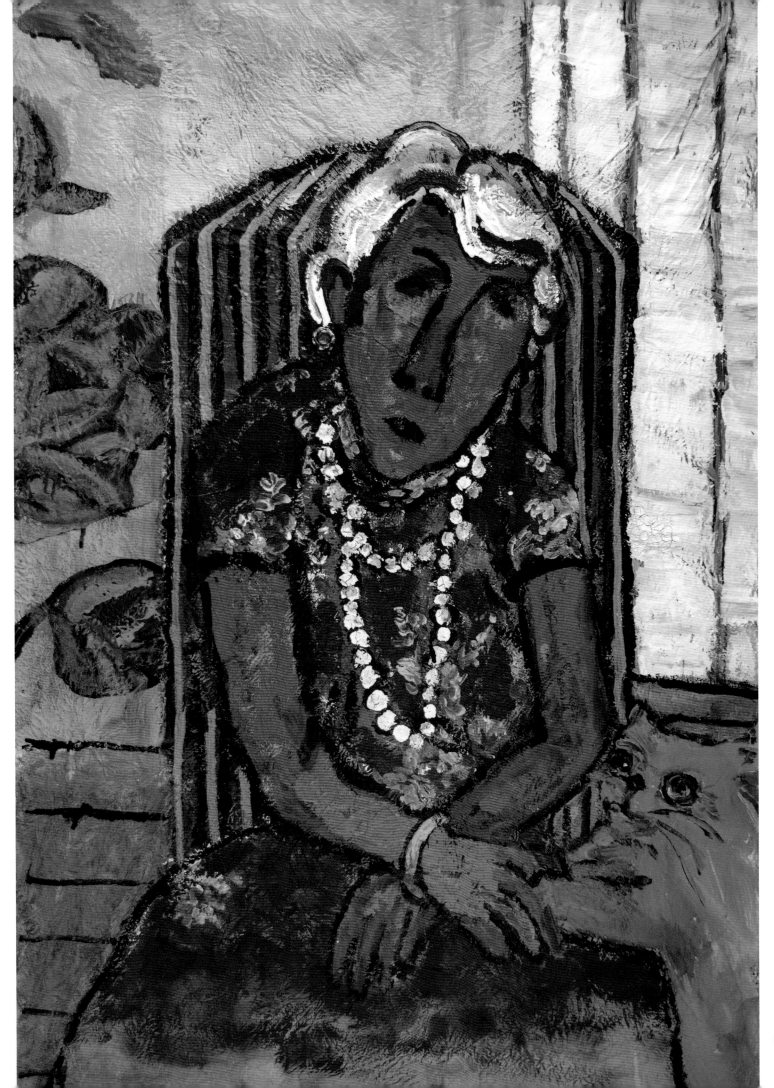

黑美人 Black Beauty

皺紋紙 壓克力顏料 廣告顏料
61×91cm
2018

　　高更在大溪地的系列創作，也許是深膚色女性的裸體首次在藝術中大量示眾。然而，相較於高更采風式的側寫；畫中的黑人女子自我敞開、獻媚，更近於義大利畫家亞美迪歐‧莫迪里安尼筆下的裸女之姿，並在她們含情的自我陶醉之上，增以一份自信的蠱惑。在法國畫家馬奈名畫《奧林匹亞》中，尚只能侍於榻旁的黑人女僕，終於反客為主；長期把持審美主流的「白」，則退居為鑲邊的飾線。

　　背景分割為若干色區：若說藍與金猶能視為女子的床褥，後方的黑色與粉橘則像張開一方密穴，不知所往。黝黑的遮掩，粉橘、而近似肉紅色的入口，經女子撩人的姿態點撥，都沾上了情慾的色彩。慵懶，是身體最沒有戒備的狀態。但我們能隱隱感受到，這股慵懶從來只是偽裝；女子看似繳了械，實際上卻是最大的操戈者，視觀者幾乎如囊中之物。

　　即便是同一張紙面上的創作，紙紋與不同色彩的碰撞，竟也賦予每個色區相異的視覺效果。金色處儼然敷了金箔；但遇上黑、棕、粉交織的軀體，女子的肌膚不再煥發傳統裸女畫的瑩潤光澤，倒像一片裸裎的粗實岩面；陰柔線條注入了陽性的剛健，一股野性之美油然而生。明目張膽的挑逗背後，也蘊含了畫家挑戰裸女畫傳統的企圖心。

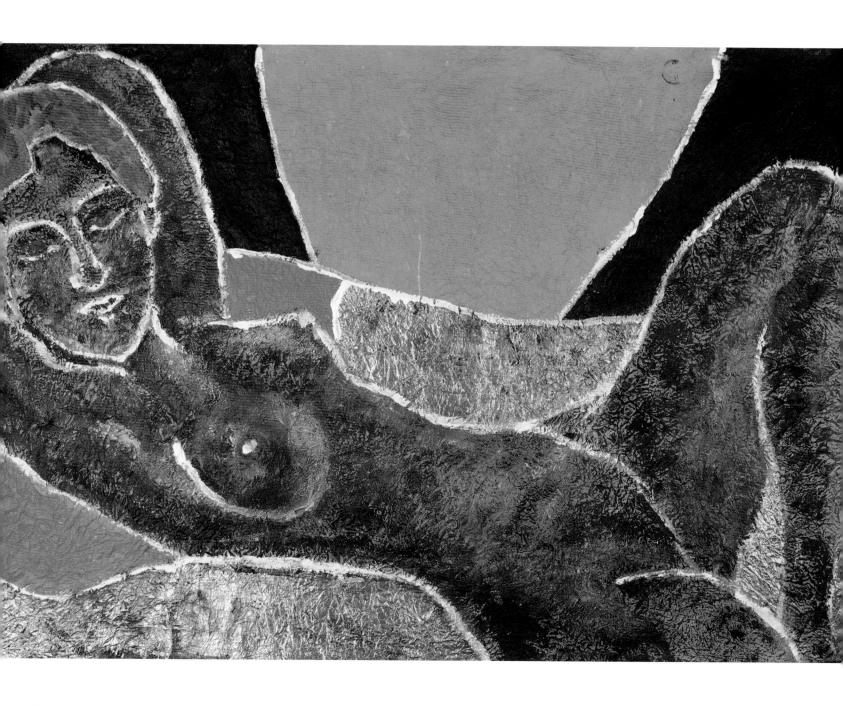

吶喊　The Scream

廣興紙寮五彩紙　壓克力顏料　粉彩
76×140cm
2017

　　恐懼，是人類最原始、故也最頑強的情緒之一。它是生物避危圖存的根本機制，即便在最安逸的眠夢裡，也可能搖響勸戰或促逃的警鈴。是以對生存困境愈敏銳的藝術家，愈能看見鮮花裡的毒草、靜水下的暗礁─或者如孟克─在晚霞蒸蔚的浪漫暮色中，看見大自然對人類的無情剚刺。

　　在孟克《吶喊》的基礎上，本作徹底抽去了實體空間與景物，一張無所憑依的臉譜空懸。暖得灼人的橙紅色退潮，我們踏入了晦暗心靈一隅，無底洞般的怖懼吞噬腥紅血肉，一種更為原始的生死恐慌撲面而來。白筆像是托腮的雙手，又像象徵衰老的白髮，平衡了畫面的沉鬱同時，也將驚恐的力道推向高峰。

　　對孟克《吶喊》的習仿，是一段以前輩藝術家心靈為鏡，見人見己的旅程。因為有了那些已披露的情緒，畫家得以用裸裎的心體與之相印，與異地異時的那個聲音交換恐懼。一位作者在作品中的自我揭露可深可淺，但當千頭萬緒，化約為一張瞠目結舌的臉孔；當畫家發現，除了直接以表情自我代言外別無他法；我們應有理由相信，自己已踩上了畫家的心靈底岩，踩在了那生之大本感到威脅、「恐懼」本身當體呈露的時刻。

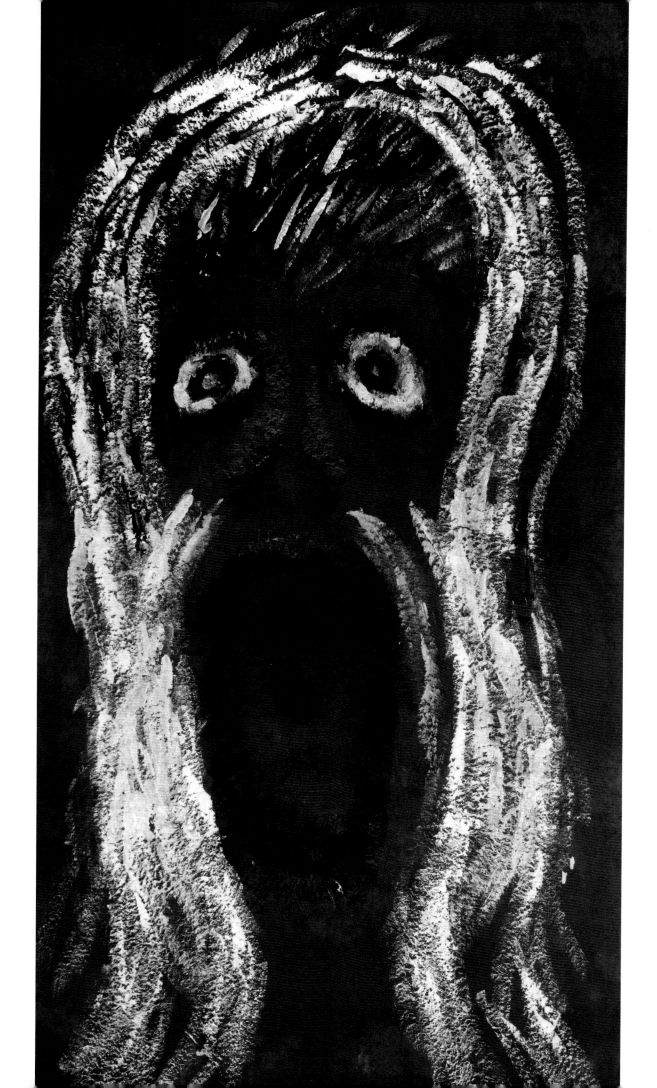

勾勾纏　Being Entangled

廣興紙寮五彩紙　壓克力顏料
65×97cm
2018

　　第一眼，一尊女性肖像躍入眼簾：嫻靜、若有所思、且泛著寡淡而遠人的螺甸紫。這副神秘氣質當即擄獲觀者；於是，要待畫面左方的人形浮現，恐怕就留待第二眼的注視。這次是位男子，由白線迴繞成形，介乎顯隱之間、實幻之際，從後方張望著甚麼。也因為沒有更實體的形象，情緒或者動機都曖昧難辨。

　　一旦兩位主角雙雙現形，我們終於能、也不免要接著叩問──他們是甚麼關係？勾勒成男子輪廓的絲絲縷縷，向女子延伸、纏繞，一圈又一圈地裏縛，幾乎宛如蠶在織繭，畫題《勾勾纏》也由是而生。也許，從女人背向男人、凝睇遠方的姿態、我們可以揣想一齣男子追求不得、又鍥而不捨的戲碼。抑或者，鏤空的形象早已諭示男子存在的不實──他可能是一段難以擺脫的回憶、一個無法割捨的念想，勾勾纏地禁錮住女子的生命。

　　在這件作品中，我們幾乎看到一種莫內式的色感：青藍色系染開憂鬱的基調，卻因幾抹黃綠的調節，而兼容了一份輕盈嚮往。流線那無窮柔韌的特質，更讓畫作中的時空隨著紋線一同扭曲，宛如夢囈。「線」是流動、是傳導、是連接；卻也是綑綁、是羈絆、是治絲益棼。它自身意象的複雜性，交織著兩位身分不明、關係未確的畫作主角，允諾了無限的玩味空間。

綠女人 The Woman with Good Serendipity

水彩紙　水彩　壓克力顏料
96.5×33cm
2018

　　對於創作這回事，文藝復興巨擘米開朗基羅曾作驚人之語：
「其實這形體本來就存在於大理石中，我只是把不需要的部分去
掉而已。」此話一出，創作者與其作品的關係彷彿發生了某種質
變。「製造」成為一個太俗氣的詞；「發現」，或者「際會」，
似乎始足以定義這種新的耦合關係。

　　在對創作媒材之信靠這一點上，畫家與米開朗基羅是相近
的。所有畫家，大抵都擅長駕馭顏料；但不是每一位都能撇開膽
子、信馬由韁，讓顏料自行創作。在此作品中，畫家潑灑綠色顏
料，讓他們落定的姿態、流路，自由發展出作品原型。橫橫豎豎、
曲曲直直，成為畫家因勢利導，加以孵化出形象的幾何基礎。顏
料，成為帶領畫家，抵達創作終點的引路人。

　　截然不同的是，米開朗基羅貌似謙卑的話語背後，實帶著胸
有成竹的豪氣；畫家胸中則一無所有，一無所住。他純以一副隨
遇而安的直覺，在線條中勾勒出一位柔美無比的女性身影。後方
規整的網格，更襯得她身段柔軟；她微微弓身，手臂婉約折疊，
整個人像一株無法盡情舒展的綠蕊。抹去了五官的臉，讓我們失
卻真正認識這位女子的機會；但正因畫家極簡化了一切主觀的加
工，我們更能著眼於線條到形象、無機到有機的偷渡與機轉。在
畫家一系列女性畫中，此作誠然給予我們大不相同的審美趣味。

林中馬 Horses in the Woods

厚棉紙　壓克力顏料
62×90cm
2018

　　每一幅畫，均是顏料與紙張的對話；但在這件作品中，紙紋尤其扮演要角。穀浪般的紋理流過筆觸、流過顏料，分明是乾筆，卻因而被賦予一種潮濕的質地，宛如透過雨天的窗觀看世界。紋溝密匝匝留白，更為畫面摻上一層雨雪。雪林，棕馬，像是雪景球內的尺寸乾坤；幾下搖晃，雪花便颯颯抖落。

　　同時，畫家筆下的雪地，稍加留心，便不難看見其下的粉綠相參。畫家自言，本打算畫一片草地，因覺不理想始又刷白處理。不刷則已，一刷之下倒收點鐵成金之效：皚皚白雪披落，參差透著花草的芳信，一種雪霽天將晴的臘春氣象。

　　這是一件構圖井然的作品，遠、中、近三景層層析開，切得分明。遠樹交織著藍天，影影綽綽的一片青藍，不似一般畫家筆下林木深處的幽暗。至於近樹，筆直而頎長，幾乎像是某種紋飾。樹林雖往往是障蔽的、掩映的，此處樹木寬綽的間距，則使得視覺上無比清透；縱然馬隻背對著觀者，我們仍能略無所礙地、第一眼看清這個自由且從容的群落。

　　家馬溫良，野馬不馴，一般畫家多強調二者相異的風采；若畫馬群，亦多描繪牠們齊奔的飛揚與壯闊。這幅畫作，選擇將野馬群安頓在一片寧靜、無擾的雪林中，不焦不躁，不奔不跳——彷彿終有那麼一遭，牠們不必再兜售英姿、賣弄氣力，而是真正地走入了大自然，在其中呼吸，吐納，並無所事事地，存在。

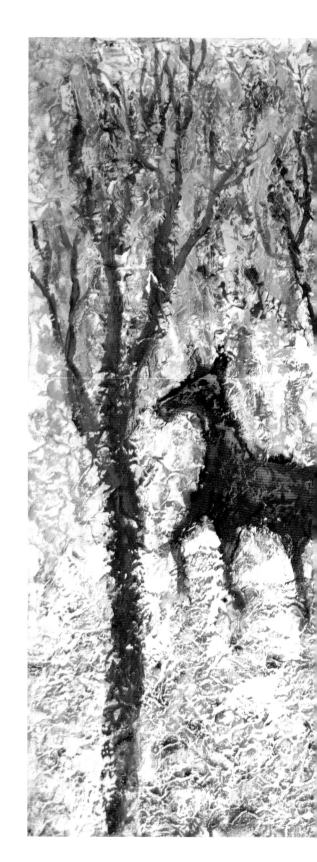

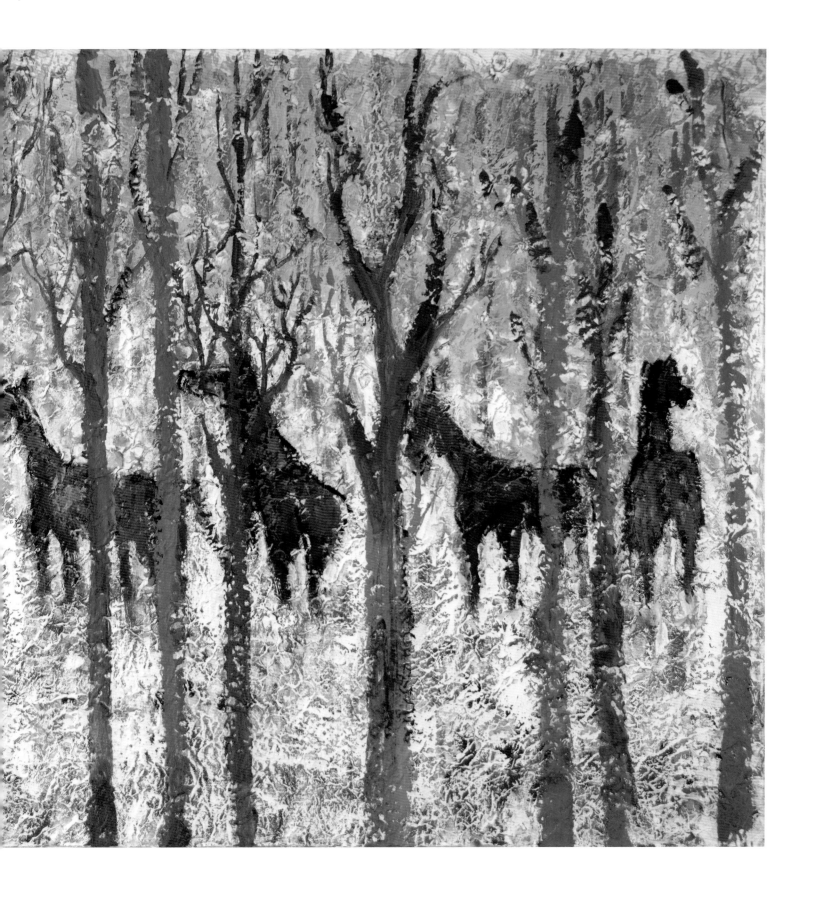

親子之愛　Love of Parents and the Kid

宣紙 水彩 廣告顏料
69×137cm
2018

　　最能與意外共處的事業，無如藝術創作。以這幅《親子之愛》為例—畫家本在紙上貼了塑膠繩，端詳再三，總覺差強人意，才毅然決定撕去；這一反悔，倒柳暗花明地留下一條條遒勁、乾脆且別具風骨的撕痕。

　　一輪焰色瞳孔似的深淵，在底部睜得碩大；白線在其上此去彼來，交織成網。猶恐圓與線的基本構圖落得單調，畫家添上一大一小兩隻瓢蟲。象徵生機的瓢蟲，此刻卻身陷危機的當下；其甲衣紅寶石般的光澤，也彷彿成了報險的警示燈。這幅畫，遂一變而為一齣行動劇，展示生命在險境之中，與另一個生命的對話。

　　這個場景究竟訴說怎樣的故事？畫家自己給出了兩種敘事。也許是小瓢蟲孤勇挺進，想搭救受困蛛網中的大瓢蟲—一個關於「孝」的故事。又或許，是大瓢蟲以為孩子受困，急急前往營救，反而自陷羅網—如此，這便是一個「慈」的故事。孺慕也好，舐犢也罷，流露的均是親子之間那近於本能的「愛」。因為這份不得不然的親子之愛，所以孤身犯難，所以關心則亂。

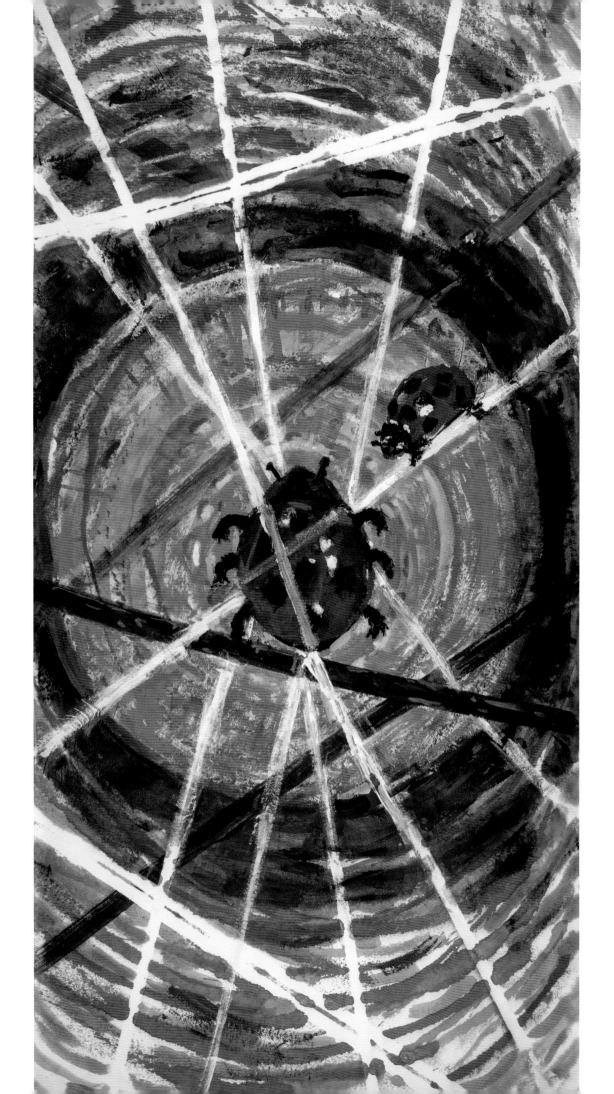

真空妙有 Fancy Vacuum

宣紙 水彩 廣告顏料
76×141cm
2018

承襲《青春舞曲》，《真空妙有》仍以幾何色塊堆垛出似幻的場域。它們構接而成的彩色立面如一只稜鏡；這種工具將白光折射成彩，寓示現象表裡之間，某種一無定態、互相轉化的關係。至此，稜鏡的作用，已相當逼近佛教對真實的關照；「鏡喻」也向來是佛教中卓具意義的譬類，勘破世間萬象鏡花水月的本質。

湛藍顏料深處，兩隻貓鏡像般雙雙浮現——這是畫家留下的關鍵線索；畫名《真空妙有》的旨趣，就寄託在這一物二相的巧設之中。如來藏言「真空為體，妙有為用」，意即萬物本是「空」的存在。它們沒有本質性的構成或賦予，僅僅是因緣條件瞬時的輻輳、聚合，緣起則生，緣滅則亡，此是為「空」。至若我們所感知到的這個現象界，真切無比，卻不是究竟真實，遂姑名之為「妙有」。如果畫中的兩隻貓，是鏡面兩界的真身與虛像，那麼孰虛孰實，何從辨識？透過斑斕卻混濁、難以一眼穿透的設色、不篤定的空間感、以及高度概念化的物象安排，畫家挑戰我們對虛與實、空與有的觀看方式。

無論是在畫風上或主題上，《真空妙有》均是一次跳躍，與畫家從前的作品大異其趣。傳統禪畫訴諸空無縹緲的意境，直接敲響性靈；這幅畫則用更幽隱的象徵、豐滿的畫面，讓佛理以一種十足反傳統的風貌自我呈現。可以說，畫家抱定不甘墨守的野心、變動不器的創作路數，本身就是將諸行無常、變即是常的佛學體悟，真正落實於藝術實踐。

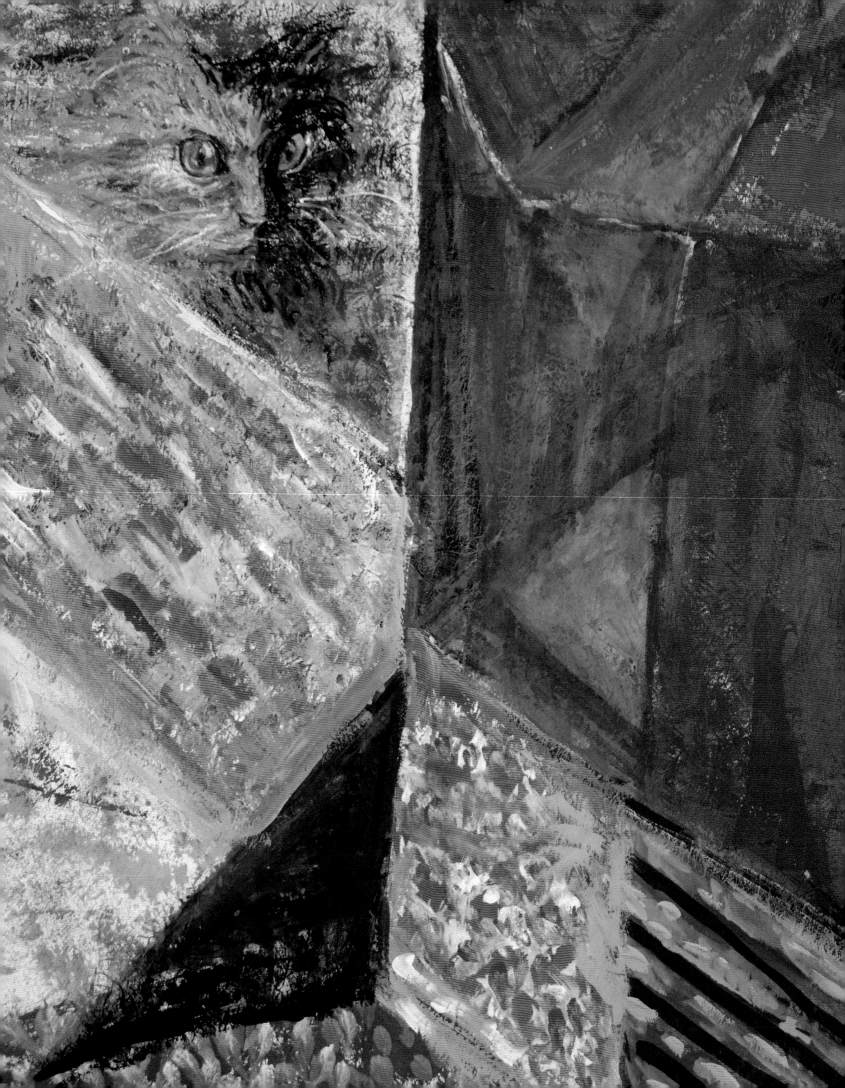

慟 In Grief

廣興紙寮五彩紙　粉彩　廣告顏料
140×78cm
2017

　　恐懼是扎根於心靈結構底層之本能，悲傷則非──悲傷是進階心智能力的產物，它可以更細緻幽深、更曲折多慮，是以《吶喊》式的、簡明有力的正面呼救已不敷在此使用。與之相稱的表現方式，難免抖落原始衝動，代以千瓣藏一蕊的欲語還休。這並不意味著悲傷有絲毫減損，相反地，「慟」的力道瞬間，防不勝防地打入胸臆。不同的是，說話者有意無意地將自己摺疊起來，這點從畫作形式即可窺一斑。側臉拼合為正面，正面復析解為側顏，面孔就這樣不斷繁衍、裂解與消亡，每個有機整體都割讓出局部，以成全他者的局部。單一視角的無法久恃，在立體主義畫作當前暴露無遺；必須一再自我推翻的觀看體驗，注定讓觀者左支右絀、騷動難安。觀者穿梭在一片片臉之斷章中，每在以為捕捉到正面之際、那些破碎的面容又倉皇別開。我們看到那不能率然攤開的心事，如何躑躅在顯與藏之間，以支離的視角為煙霧，吞吞吐吐地開展悲傷。

　　眼與嘴幾乎是相同的形狀：沒有內容的黑色裂口，懸置在翕張之間，近似一道道無法縫合的瘡疤。眼不願張、口不能言，讓無處導洩的悲傷囤積至臨界點；而右方臉上的兩滴清淚，如此微小、如此克制，卻是一切情緒的引爆。在一片濁灰色的壓抑氛圍中，聽不見動地的哭嚎，兩滴白淚已是悲傷最外顯的形式。可以說，這件作品是畫家難得脆弱的剖白。社會角色與性別角色的約制，讓這滴淚流得無比艱難，但也唯有當畫家踩在「畫家」這個身分當中，悲傷始有所寄，始有筆下的分身代為哭其所哭、慟其所慟。

　　這幅畫背後的詮釋可能，與畫作本身的多角性同等複雜。推其情以及人，它也可以是普世之慟，影影幢幢的臉孔則是「新鬼煩冤舊鬼哭」的眾聲喧嘩。但無論如何，所有的悲憫蒼生、所有的民胞物與，都必以自身為原點。我們不可能跳過自己去觸及他人；正如我們不可能跳過自己的悲傷，去真正讀懂這幅畫。而這一點，也許是畫家給我們最殘忍的考驗。

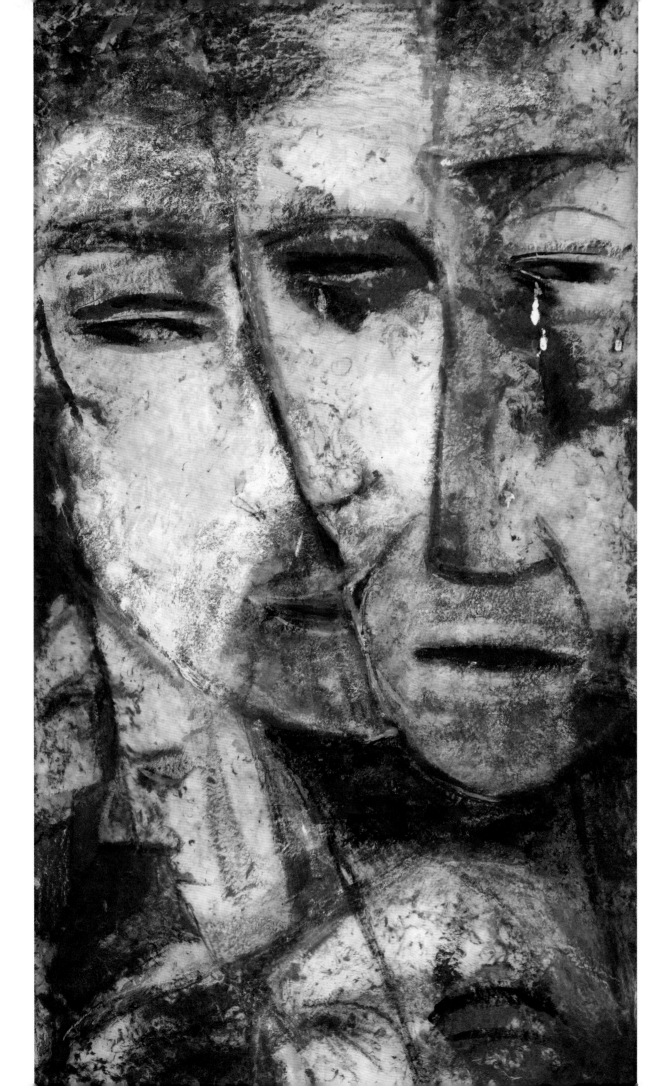

不動明王 Acalanatha

宣紙　壓克力顏料
137×69cm
2018

　　佛教密宗中的不動明王，是慈心「不動」、智慧光「明」之謂。祂以「左眼俯視，右眼仰視，周身火焰」的形象深入人心；藏在這尊忿怒相後的，卻是「見我身者發菩提心，聞我名者斷惡修善，聞我法者得大智慧，知我身者即身成佛」的宏深誓願。

　　紅、藍、黃、綠四個原色、次原色的組合，以及濕筆大面積塗抹，所賦予顏料飽滿、勻和的質地，均如某種原始生命力的沛然湧動。儘管作品只是額、眼、鼻的局部特寫，其額上的火叢、怒挑的雙眼，均捕捉不動明王的懾人威儀。祂身披智火，佛教語稱為「火生三昧」，本是要「燒諸菩薩廣大習氣煩惱」。但那象擬性器、惹人矚目的鼻形，自成一個視覺上、象徵意義上均十足強勢的符號；畫面上方的熊熊烈焰，也由是燒出了慾火的意味。

　　明王板起怒容，意欲使人自束心魔；與此同時，祂的面像本身卻又是欲念的溫床。透過物象雙關，畫家埋下作品的二重性，也把詮釋的空間，或說詮釋的麻煩—那令人或覺羞赧的解讀權—丟給了觀看者。乍看如同一個促狹的惡作劇，細細咀嚼，卻是分從俗身出發與從神格出發，人神兩股力量的碰撞與競合。

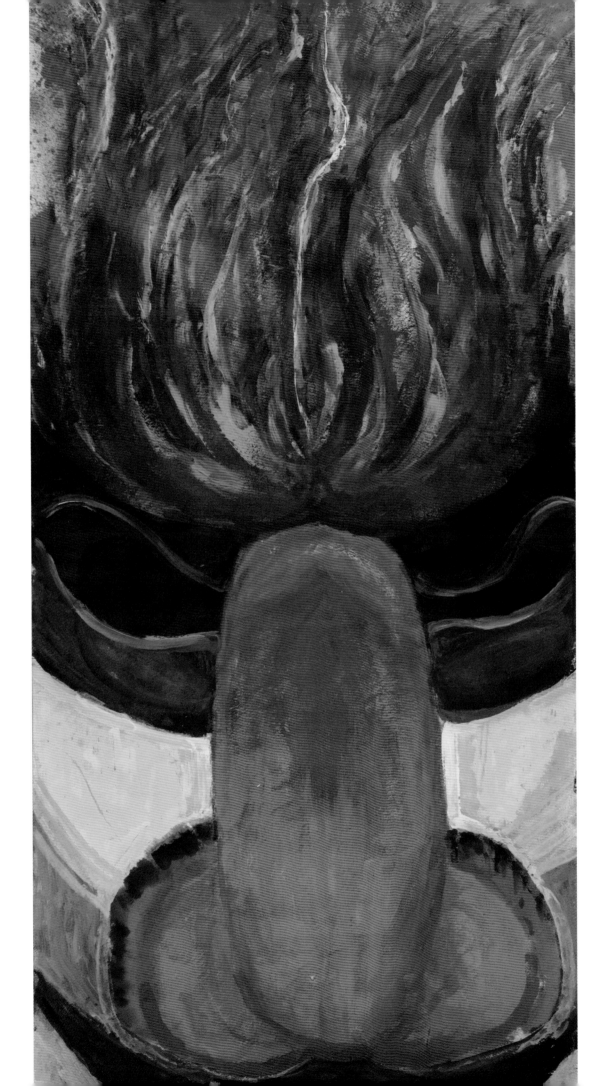

三叉路　The Forked Road

廣興紙寮五彩紙　壓克力顏料
98×65cm
2019

　　柔而近媚的天幕、色彩玄混而氤氳的大地、抹滅了五官的騎士與馬，均賦予作品一種迷醉、仿夢的特質。但在很多方面，與這幅畫的交涉都是一種不盡純粹的、帶有距離感的經驗。它游移在唯美與詭譎之間、希望與絕望之際，毫釐的感受力之差，便足以去之千里。

　　一片童話般的粉色天空搶眼無疑，但目光繞不開、也濾不盡的，卻是那蟄伏在後頭，隱隱透出的灰階，似乎預告一場暴風雨的來臨。而湛藍明亮的海域，添上那三兩座礁石、鼓搗其間的浪花，竟也藍得有些驚心動魄。一切美景，在這張畫布上都帶有保留，以及幾許拒人的意味。至若大地——望著如此斑斕多彩的大地，我們猶能察覺到，自畫面底部的近陸向海域延伸，飽和度與彩度漸次下降、且愈趨氤氳。彷彿真正多采多姿的都被拋在來路，三人三騎跋涉到此，已是末路天涯。

　　馬本是極具動態感的動物，此刻他們齊齊裹足、馬首萎垂，幾似擱淺。刻意含糊的形象，難以透漏畫中主角是誰、何所從來、向何處去；但三人各自指彎一方，不經意繞成一個沒有出口的迴環，已然留下些許關乎畫題「三叉路」的端倪：畫中沒有一條實體三叉路，然而一班人馬，各有所向，何嘗早在心中分道揚鑣。天下合久必分、聚久常離的魔咒，大抵就是那天幕後的烏雲、藍海中的暗礁，也是畫作浪漫面紗下，最蒼涼的啟示。

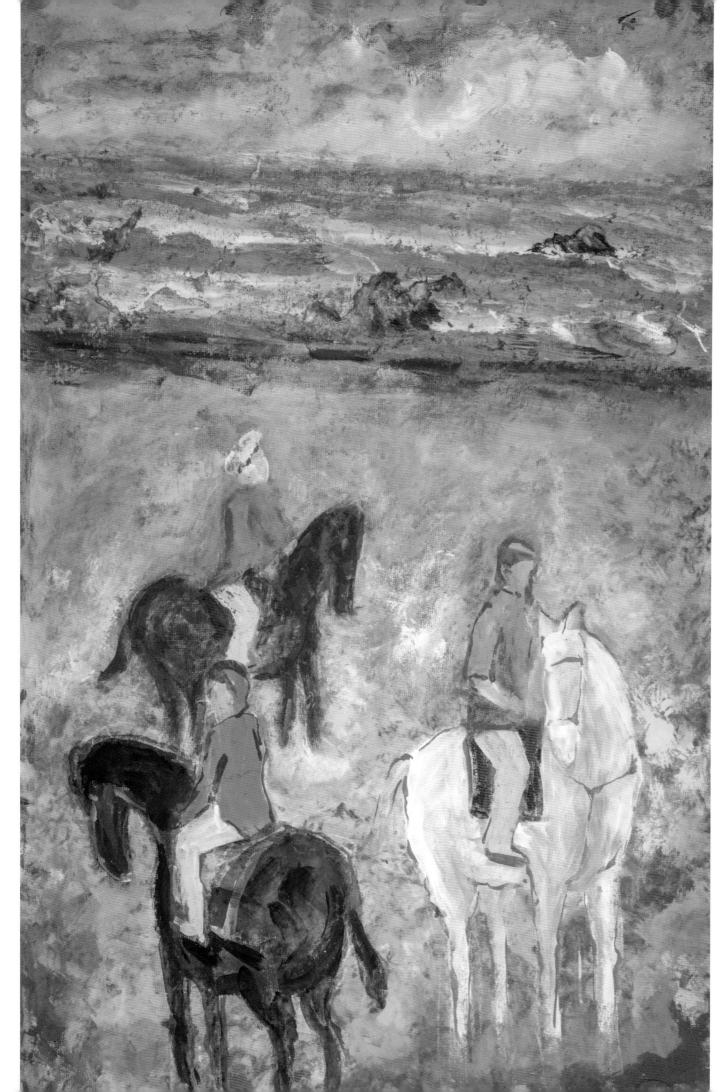

情定威尼斯 Romance in Venice

宣紙　水彩　廣告顏料
136×69cm
2018

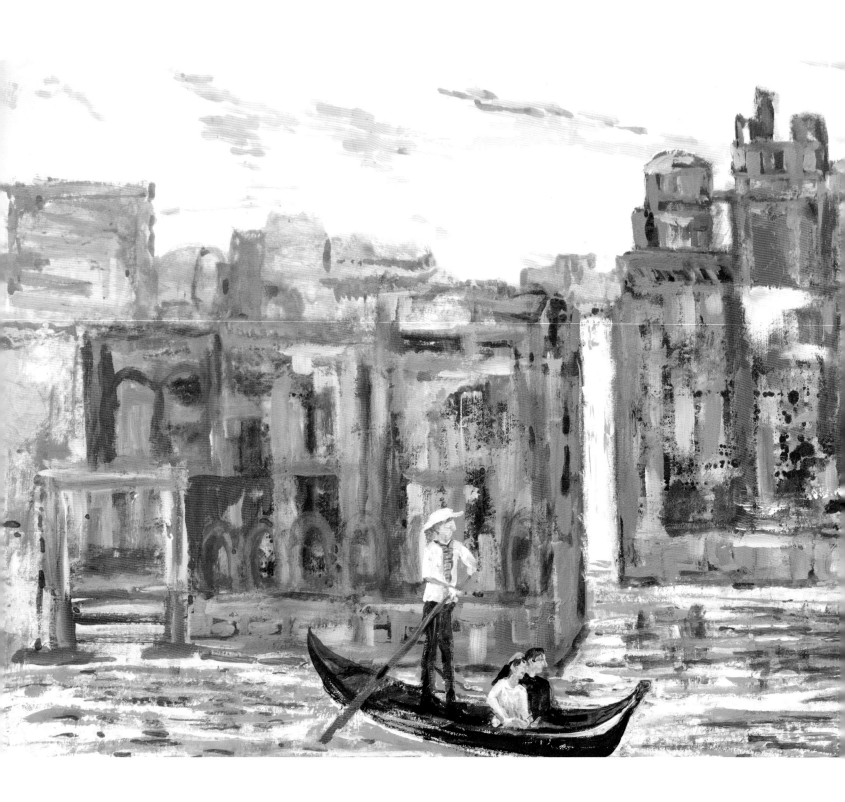

　　水都威尼斯，向來是眾多藝術家的繆思—即便是只存乎懸想之中。未曾親蒞威尼斯的畫家，以想像力、以二手經驗資給的素材，構築像《情定威尼斯》這樣一幅幻設的地景。紅藍對比的配色如明信片般鮮明，各自以河水、房舍的形式向水平、垂直兩個方向延展；它們卻又非各自為政，而是以一種「你中有我，我中有你」的姿態相互熔融，就像弱水的柔軟與磚土的堅實彼此包容，重塑為一種剛柔並濟的質地。

　　同時，畫家有意提防過度濃稠、飽和的設色壓沉了畫作的調性，於是遠景的大片留白、河面密匝匝的刷白，均讓威尼斯沐著明亮白皙的天光，宛如神所。理當遊人如織的威尼斯運河上，唯有一艘貢多拉在水流的韻律中晃蕩，載著互相依偎的愛侶，恬醉於良辰美景中而不知所之。河景早已不是純粹的河景；粼粼波光中那銀閃閃的、藍澄澄、紅融融的，無非盡是情慾的流動。

　　《情定威尼斯》固然是一幅風景畫，但它呈現的風景毋寧說是「風情式」、「情調式」的。當雙眼無法親睹，心靈之眼便睜得格外清晰。抽去了畫家投射的、「水汪汪的深情」，這座想像中的、澄明而溫柔的威尼斯，便不能獨存。

豹王 The Panther King

廣興紙寮雲龍紙　壓克力顏料
96.5×63.5cm
2018

　　若說金獅、猛虎以沖天的氣力、動地的怒吼，略無懸念地堪稱獸中雙雄，僅次之的第三大貓科動物——豹，似乎以一種更為神秘、迅捷、陰狠的形象，在吾人的群獸聯想中佔據幽暗一隅。牠們獨來獨往、行蹤隱密、常匿棲叢中；儘管黑豹只是豹類中的少數黑化個體，這樣身披一襲夜色的形象，與其性行特質可說十足匹配。

　　在波譎雲詭的商界打滾大半生，畫家對「適者生存」四字深有體悟。獅、虎、豹均曾是他筆下主角，而這些令人聞風喪膽的高級掠食者，猶需奮力狩獵、性命相搏，乃能在自然界掙得一席、甚或只是苟延一息。這些猛獸是僥倖的勝者，卻也是生之意志與能量的化身：畫家不厭其煩地以紙筆捕捉彼之精魄，當非偶然。

　　黑豹已自不凡，這頭浴火重生的黑豹尤然——牠踏著熊熊火路挺進，圓睜的怒目裡，閃爍的是一種危急之秋當前的存亡恐懼；但牠裂開獸吻，大張鋒利的獠牙，壯起聲勢以釋出威嚇訊號，誓要教來敵怖畏而去。牠在急難之中正面迎敵、甚至轉守為攻，儼然一股君臨天下之風，實在當得起「豹王」二字的千鈞加冕。

　　畫家用筆精煉，一一可辨：以藍筆加重豹身輪廓，使肌肉線條更顯剛健，也大大突出了豹隻形象。雲龍紙纖維經黑筆一刷，散碎為亂麻般的紋理，視覺上千鈞一髮的危機感更甚。大明大暗的橘黑對比，是畫作張力的主要來源，召喚起暗夜野火的野性聯想。火往往照亮、或者某種意義上吞沒黑暗；但在此作品中，黑豹才是從赤焰中突圍而出的那道勢力。當豹王戰勝了烈火，那瀰漫火光已不再是危機的象徵，反而像是一襲燙金戰袍，輝煌歌頌著豹王的傳奇。

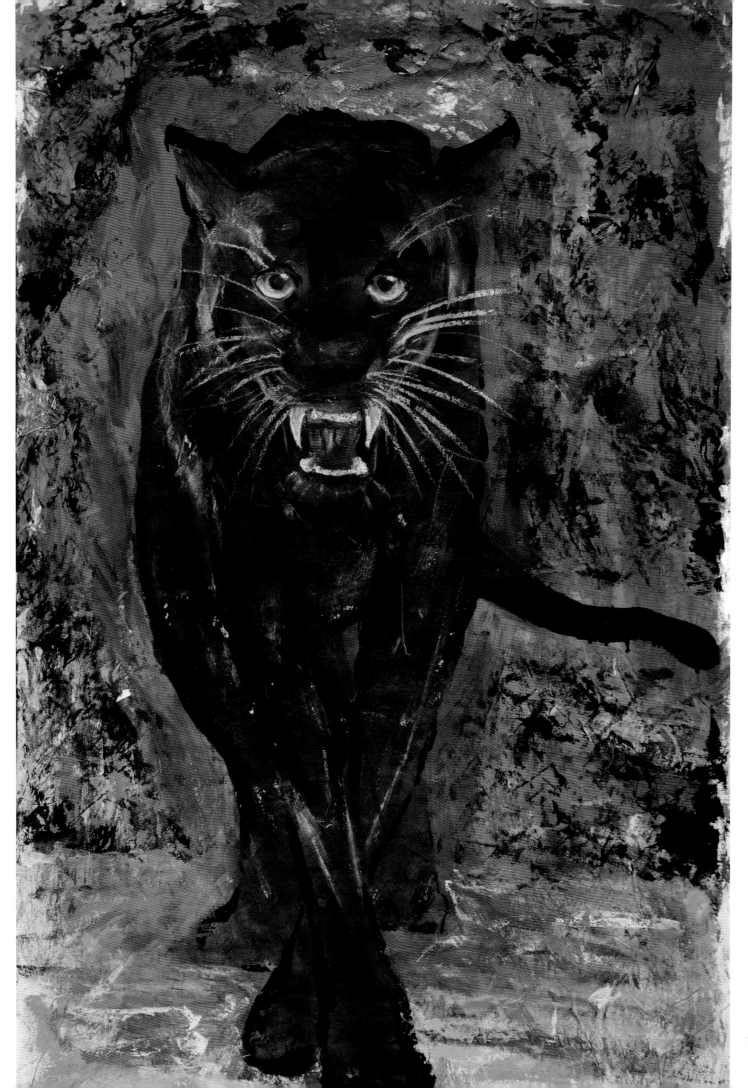

情竇初開 The Dawn of Love

廣興紙寮五彩紙　壓克力顏料
65×97cm
2018

　　青春，是生命中「嫩綠輕黃成染透」的時節。畫中女子，正像從連天綠黃中生長出來，儼然一尊青春仙子的形象。她一手遮胸，像是猶抱琵琶的含羞，卻也依稀如孤芳自賞的撫觸，帶有對自身軀體初探索的羞赧與驚異。而隻手遮沒了的左胸脯，恰恰是心口位置；這樣的姿態，因此成了性徵與心事的雙重掩抑。

　　在一個身心都甌欲綻放的年紀，女子的自我斂藏，也許正是她神情中淡淡哀傷的根源。本該光采煥然的眼眸，因為缺乏凝視的對象而沾染了惘然，視線失神、也失焦地流著浪。品讀女子形象，髮、眉、眼是一以貫之的鮮綠，唇卻不然。那對粉唇如蓓蕾，含苞未放，但已薰染春色——女子的心事，因著這一抹粉嫩的血氣而透明起來。

　　我們於是意識到，這並非等閒心事，而是一樁有著悠久傳統的心事——「恰三春好處無人見」，自開自謝的春色、自生自滅的春情，是每一位剛剛學會「發現」自己的少女，心中所揣的至深焦慮。早自《詩經·召南·摽有梅》，花期空等的悵惘，或者情竇初開的患得患失，就成了她們幾乎約定成俗的共同憂感。眼前女子，輕盈地近乎出塵；但在她身後，那些濃筆刷下的橙綠筆觸，似乎宣讀了她內心某些飽脹著、渴望排遣的部分。浴火盛開的白花，象徵熾烈情欲與純潔心靈的並存；它們恣意招展著，要證明二者從來並不互斥。

　　少女情懷不唯是詩，更能入畫。美好中有善感的酸澀，酸澀中又注滿希冀的美好，這興許即是青春的本質。

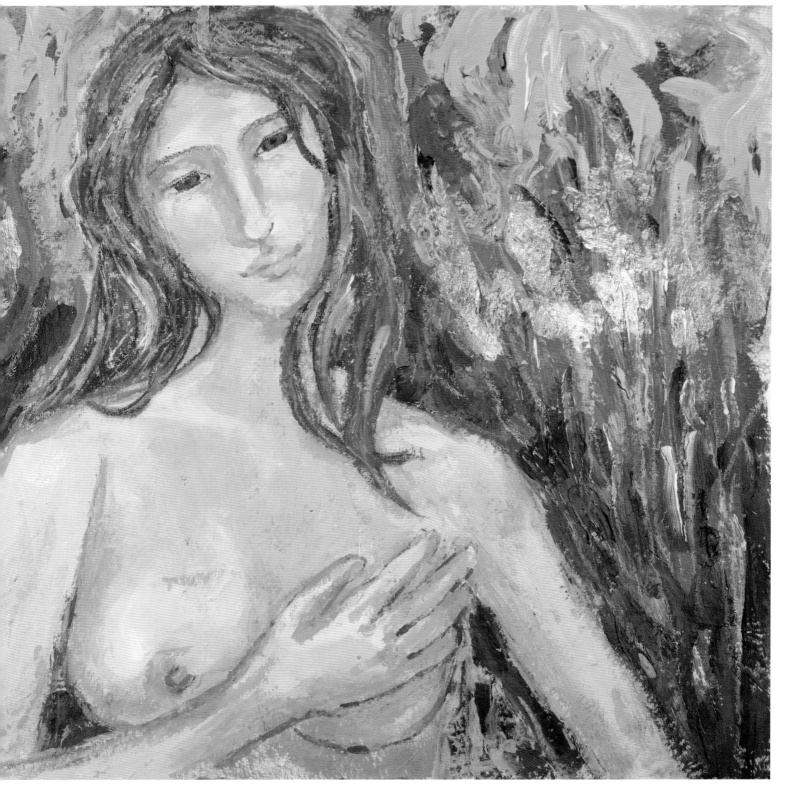

動靜之間　Between the Status : Dynamic vs.Static

廣興紙寮雲龍紙　壓克力顏料　水彩　廣告顏料
95×188cm
2017

　　畫家多次提及向大師致敬──常玉對他的影響。縱觀常玉後期一系列曠野、動物的作品──一、二隻零星動物疏點著廣袤空間──不難在本作中拾其殘響。但這僅是就空間布局的大項言之。《動靜之間》的精神樣態，實與常玉那份一則可親、一則寂然的魅力，大異其趣。

　　畫面遠方，一支灰色陣伍浩浩蕩蕩、卷土揚塵而來。那是非洲大陸上四季遷徙的象群，一步步均踩在季節的拍點上；牠們體龐且勢眾，即便只是一行形象曖昧的灰影，也足以感到其氣場迫近，伴隨著撼動天地的象鳴與步踩。相形之下，原野中央一坐、一臥的兩隻白豹，如此恬然自得。那份以靜制動的王者氣象、甚至帶些「天地於我何有哉」的不遜，讓牠們在尺寸、數量上的弱勢顯得無關緊要。畫家喜畫豹，《豹王》中的黑豹浴火重生、十足霸氣，此處的白豹同樣毫不遜色。

　　同時，作品的色調卻又柔美如斯。大地不是習見的土黃或赭紅，而竟是「潑黛揉藍畫不成，暝色仍含紫」的山梗紫，襯著日色倒瀉所染就的金黃天幕，幾乎將非洲莽原上、混雜著泥土與動物體味的粗獷氣息，都滌蕩一空。畫家在空間、色彩與物象對比間，一次次搬演魔法：於是第一眼的空曠、寧靜，旋即被逼近的騷動充盈；第一眼的浪漫，迅速被白豹無聲的制霸給覆寫。他向常玉取經，卻又以自己獨特的價值觀、品物旨趣，重塑了畫作底蘊。動靜之間此刻的差距，不再是空間距離或者速度落差，而是兩物種間，精神高度與生存姿態的懸隔。

卓別林　Charlie Chaplin

廣興紙寮五彩紙　壓克力顏料
66×48cm
2017

　　一頂圓禮帽、一襲黑西裝、一撇小鬍子，我們不難第一眼辨認出卓別林的招牌形象。在相機未被發明的時代，人們用畫筆油料捕捉形容；但當卓別林的身影，或動或靜，已被鐫刻在成堆的膠卷中，為什麼世上需要又一張手繪卓別林像？它與並置的另外兩張藍色調畫作，又構成何種對話？

　　作為二十世紀最偉大的喜劇演員，卓別林深諳「喜劇均有悲劇內核」的道理；作品中最引人發噱者，往往也是對社會畸象最一針見血的譏刺。他是一名在苦難上耕耘藝術的笑匠──無論是社會的苦難，抑或個人的苦難。如在1950年代，立場左傾的卓別林引起美國當局訾議，遭驅逐出境。五年後，他將這段經歷改寫為《紐約王》，對美國政治風氣極盡挖苦。對他而言，以藝術為媒材的自我解嘲，是對內的紓解，也是對外的抗爭。生命的千鈞重擔，在包裝為笑料後，似乎還能以自外的姿態旁觀取樂、愜意下酒。

　　畫家是一名成就斐然的商界人士。必須面對更為複雜的世界，經手更為難解的難題，背負常人未必能共體的壓力，是他宿命的一體兩面。但在公務之餘，畫家幽默的性格、天馬行空的詼諧，或許正是他自我調節的策略，俾其在每次挫敗之餘、力竭之際，迅速抖落塵埃、重獲續航能量。繪畫與其說是一種雅興，毋寧說是一個出口：在一筆筆畫下卓別林形象的同時，是對卓氏化嗔為喜之本領的致意、自勉與練習。

　　合觀整個藍色系列，也許更能看到「藍」之為色的真實性格──它是眾所皆知的憂鬱之色，但更是清醒的色彩，三張藍色調作品，均建立在對現實的如如確知之上。生存的法則、生存的告誡以及生存的姿態，在三作中串成一氣；看似旨趣大異的作品，實可視為一部沉思錄，記錄了潛意識面對生命較不惻的那面，深沉洞察、自我對話的過程。

嚴母的教誨　Lessons of the Mother

廣興紙寮五彩紙　粉彩　廣告顏料
48 × 66cm
2017

　　被問及創作靈感所自，「偶然」是畫家給出的答案。由著五彩紙的花樣或紋理去馳騁想像、順藤摸瓜，一如孩童望著雲朵指認花草鳥獸、那望符生義的本能使然――貓的形象就這樣天啟一般浮現紙面。除了紋樣，畫家就著五彩紙先備的青色質地，增以蠟筆厚彩加色，經營出一個沈鬱、濁重的青藍維度。紙張在畫家的創作過程中，不只是顏料著落的媒材，本身也是一汪不斷吐露暗示、投射訊息的靈泉。

　　與色調同等壓抑的，是兩隻貓流露出的不豫神色：小貓瑟縮、克制的坐姿、無辜到無處安放的眼神，對比於大貓沈穩伏坐、平措的身軀、及微微側首投以的申諭目光，我們隱然能看見一對母子――母貓試圖在危機四伏的世界中，用管束張起一頂保護傘，讓孩子遠離險地；而調皮的幼貓，總是在滋事後才想起母親的教誨。這樣的耳提面命，在人類世界中再熟悉不過。

　　這固然是凝重的時刻，然撥開內裡，嚴母之教的本質本不離溫情。幼貓懵懂、無辜的神色向畫外漂移，增添幾分不馴、幾分頑鬧、幾分逗趣――在畫家擬人化的處理下尤然。但同時，用色單一、粗重、混沌而低彩度的視覺感，與它所包裝的故事又形成一種詭譎拉扯。畫面與內容的一輕一重、一抑一揚之間，彰顯了「管教」與「慈愛」之間莫名的衝突。

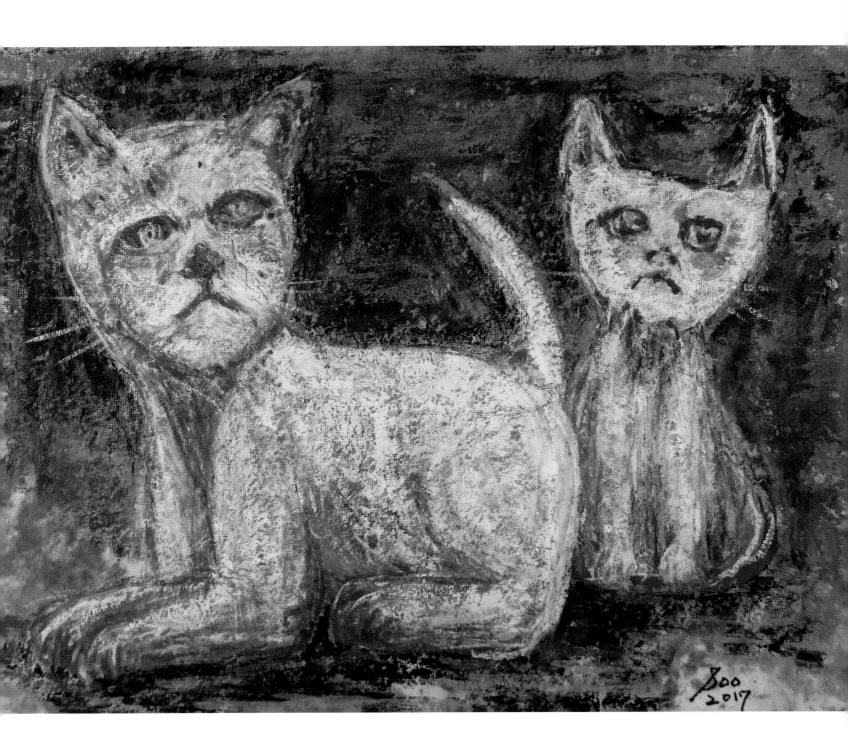

狼性 Wolf Instinct

廣興紙寮五彩紙　粉彩　廣告顏料
66×48cm
2017

　　何謂狼性？今用「狼性」一詞，似乎都強調其野、殘、貪、暴；但敏銳洞察、目標專一、伺機而動、機警等特質，才是狼隻在自然界中的生存法門。畫中孤狼，怡然不動，卻不曾稍失警醒。那對直勾勾錨定了觀者、不閃不避的雙眼，以及豎立的雙耳，均飽含觀察、洞悉、審度等一切行動序曲。有此種種在靜中完成的鋪墊，動時才能雷厲風行、精準中的。作為一位出色的企業家，會以狼作為精神圖騰，似乎不足為奇。面對商場上的攻防進退、盤根錯節的利害得失，這幅畫若非自詡，至少也是某種程度的自許。

　　畫家喜畫視覺上居中、直視觀眾的動物，有意將牠們從被觀看的地位超拔出來，賦之以或多或少的話語權。有些直視是促狹的親熱，有些則是直來直往的坦承。而畫中的狼讓人感受到前所未有的距離感：那是種攻守合一的姿態，甚至沒有針對性的情緒投射，而純是出於本能的武裝。若說同屬藍色系列《嚴母的教誨》，以親情角度觸碰生存課題；《狼性》則少了溫情緩衝，不假包裝地攤開生存要義。縱是叢林法則的佼佼者，畫家也不得不在現實與內在的拉扯間，不斷校正、尋索自己的立身姿態。

　　這道難題如何解套，是否解套，則有待藍色系列的另一件作品──《卓別林》來交出答卷。

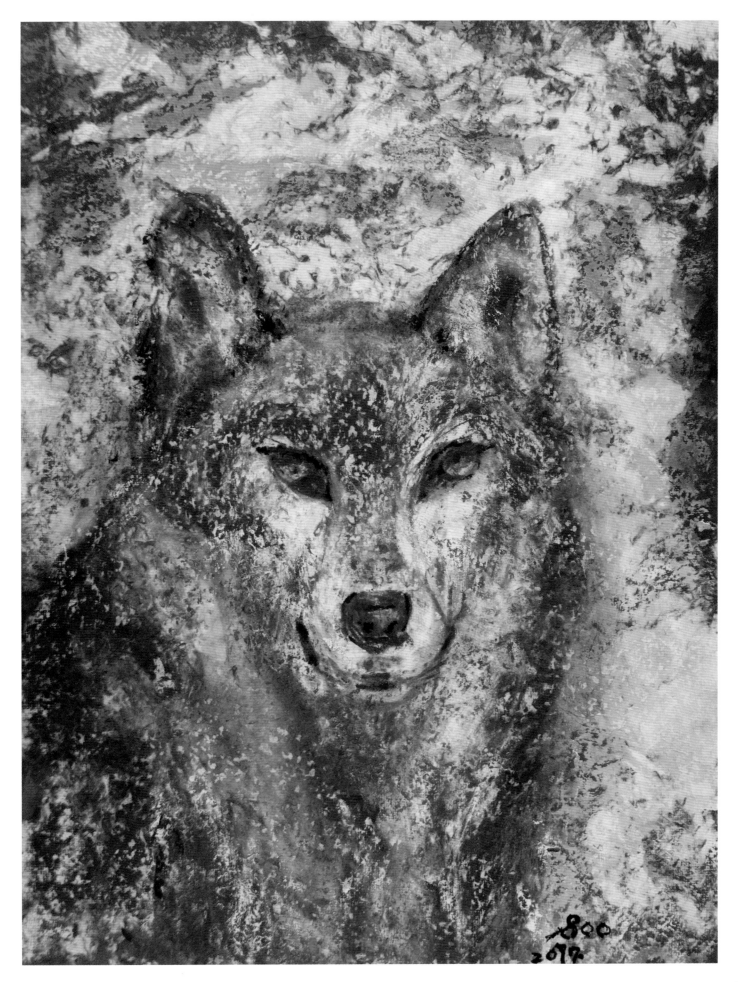

讒言　Tricky Flatteries

廣興紙寮五彩紙　壓克力顏料
51×67.5cm
2018

　　「仁而不智，則愛而不別」——這句話用來為《西遊記》中唐僧作注，最是適切。小說中的唐三藏慈悲有餘，洞察力則稍欠一籌。心智不明，也就軟了耳根，因而不時受妖言欺朦、巧舌蠱惑。以「讒言」為題的這件作品，畫的便是這口耳相接、傳讒獻媚的一刻。

　　與《貝多芬》、《沉睡的巨人》同屬青磐綠一系畫作，《讒言》白綠駁雜的粗糙質地，讓觀者彷彿面對一件出土文物——也許是具歲久生苔的石像、或者經年斑駁的銅雕，幾乎勾動人「試將磨洗認前朝」的興味。

　　察其人物構圖，讒者以側面示人，是中外畫作中「小人」的典型姿態。小人斯存，則君子何在？唐僧雖以莊嚴法相面眾，但從中心退位，面目也被邊界切割不全——要成為堪當與小人對舉的君子，似乎仍有那麼一點不盡中的。

　　而約莫位於畫作心臟地帶，兩點石榴紅不可不謂奪目，硃批般畫記出「讒言」的現在進行式。那紅豔欲滴的口舌，未知在絮絮叨叨著什麼；而唐僧耳上同樣搶眼的一抹紅，隱然暗示誹言佞語的達陣——暗示讒者的勝利。紅色從來是危險的顏色，在這幅作品中作為點題之用，則更具警世意味。

貝多芬　Van Beethoven

廣興紙寮五彩紙　粉彩　壓克力顏料
50×67cm
2018

　　幾乎所有典型的貝多芬像，眉宇間都寫有一重隱隱怒氣。而但凡對其生平粗有耳聞者，大抵不難理解貝多芬怒者形象何所自來。對一名音樂鬼才而言，聽力的喪失無啻死刑；在此近乎無聲之中，依舊不竭的產出，是以悲憤為燃料、意志為支柱的自我續命。貝多芬的音樂本身，固足以讓他名垂青史；但那悲劇英雄的色彩，將他一舉拔擢至精神圖騰的地位。

　　本作習仿約瑟夫‧卡爾‧施蒂勒於 1820 年所繪的貝多芬像，因創作於五彩紙，而被賦予嶄新色調；唯有那紅衣襟依舊紅得跋扈不羈，象徵憤怒與熱情。它與《讒言》、《沉睡的巨人》同屬綠色系列：在《讒言》中，證果成佛前的唐僧，只是芸芸修行眾生中的一位。他無可厚非地擁有人性弱點，也因為他的弱點，勢將面對柔自取束的命運。然而，註寫在他命運之中、他所背負的使命，卒將領他一次次化險為夷，遂行他在人世的修練。

　　《貝多芬》的主角，則是位徹頭徹尾的世俗英雄。他有生而為人的老病死劫、有生而為人的貪瞋癡怨；但能拿出剛健如鐵的心志，迎戰慘灰如鐵的命運，本身即是超人的表現。這一組對比，是至剛至柔的對比，是兩種命運的對比，更是「神而人之、人而神之」的對比。《沉睡的巨人》則居中仲介，似乎隱喻某種由人向神渡化、或者回歸的關係。綠色系列三作，蘊含畫家對人之弱點、承擔、自我超越的深層思考，也重新定義了神性──放下軟弱，承擔命運，或許已是畫家心目中，離人近神的一步。

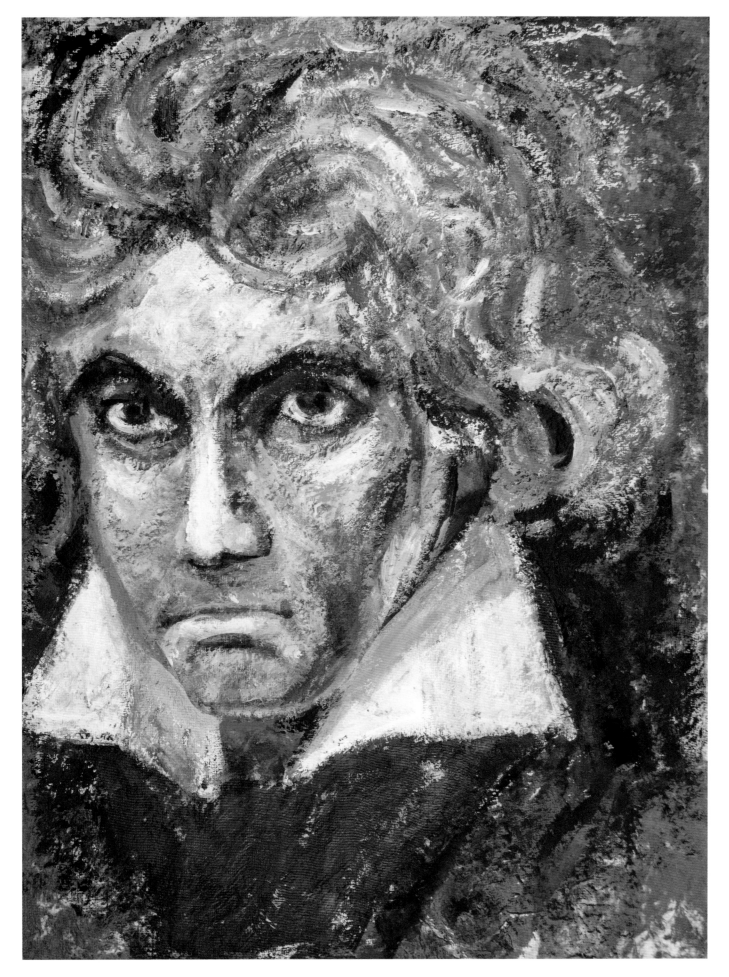

沉睡的巨人 Sleeping Giant

廣興紙寮五彩紙　廣告顏料
50×67cm
2018

　　在畫家藍綠系列創作中，所有對生命的疑問，在《沉睡的巨人》洗刷一空。我們看到的，不再是一種石窟壁畫的滄桑況味：歷史退位，神話進駐，那聲聲召喚同樣來自遠古，但已人神殊隔。人即歷史，會朽敗，畫中那位仰臥在下的巨人如是，沉沉土色的側顏像是陷入了長眠；腮下斑斑駁駁，安詳地躺著，所有重擔、是非已遠離。在他上方，青霧脫胎於無形，靉靉靆靆地，逐漸聚為巨人似的側臉，以一種來自異界、象徵神性的祥和目光，俯照寐者。

　　是來自他方世界的祝福嗎？抑或是夢境中？無論何者，我們似乎闖入了一個極私密的片刻；所有授受，都是場無聲的、不為外人道的儀式。但碧青一色，並不是拒人千里的色彩：它像一汪深潭，將觀者攬進它的神秘流域。我們未必能參透儀式的密語，但都獲邀旁觀，被包裹在此縹緲、寧靜與莊嚴中，以與生俱來、心眼相通的感受力，將之內化為一場洗滌、內觀、祝福或治癒，各取所需的私人洗禮。

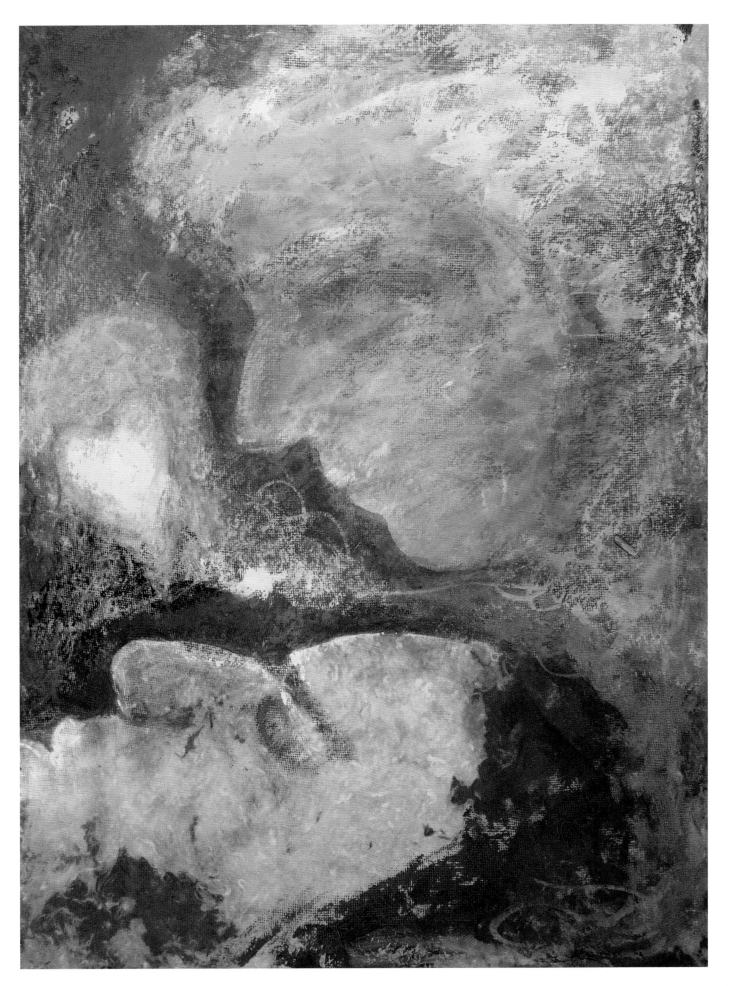

藍馬 Blue Horses

廣興紙寮五彩紙　壓克力顏料
65×98cm
2019

　　馬隻自古即是駝運、征戰的動物；馴養史由來久遠的牠們，似乎總是背負使命、疾趨他方。馬隻的頻繁入畫，既因牠們與人類生活如此密不可分，更多時候是人類對自身文明交流、商貿往來、衝鋒陷陣的附帶歌頌。

　　但在此則非。晨霧之中，一支馬群的藍色剪影，在草地上自由放牧；或深或淺，錯落綠野，一派悠哉。「繁華落盡見真淳」，也許是這件作品最貼切的注腳。《藍馬》的構圖是單純的天—馬—地水平分層，蕪去了多餘景物，天地由是顯得更為廣闊：非唯地理意義上的廣闊，更是詞義內涵上的廣闊——自成一首天覆地載，萬物自適其間的自然頌歌。而畫家簡單勾勒馬形，與其說是從個體下手、寫真馬群的千姿百態，毋寧說是以「群體」為單位，觀照牠們的整全性及相對關係。錯落之餘略呈迴環的馬群，像是象徵著物種的生生不息。

　　一抹亮黃依稀透出天際，預示天將破曉、暖意重臨，與藍色沃土上、一株株探頭招搖的、嫩綠的新翠相映。這興許是欣欣向榮前，最後的天階夜色涼如水；是萬物生機競發前，最後的休養生息。寧靜從來不是死寂：它無聲無息，不驚不擾，卻是大自然在迎接一場盛世鬧熱之前，最優雅的禮讚。

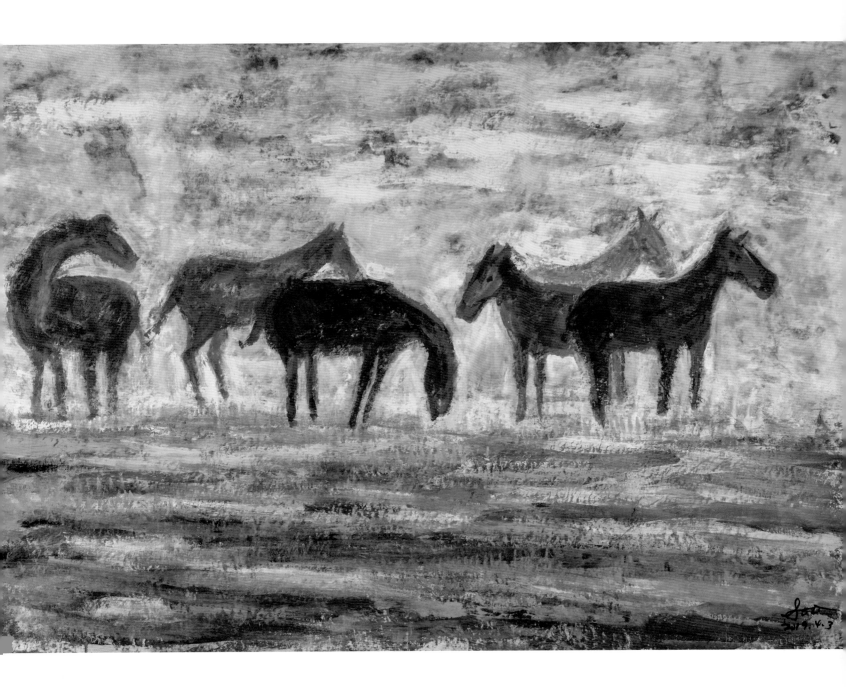

月河　Moon River

廣興紙寮五彩紙　壓克力顏料
65×97cm
2018

　　水與月，從來因其陰柔、沁冷的質似，而繫屬於同一意象群。膾炙人口的電影名曲《月河》（Moon River），以音符示現一段寧靜、淒美的獨白；月下長河幻化為歌者某種意義上的靈魂伴侶，在孤獨的夜裡，扮演她訴衷、言志的對象。

　　畫家這幅《月河》，則以顏料交織水色與月光。最初想畫的是條路，卻在察覺質感益發「液化」之際，索性順水推舟；道路成了流川，《月河》那空靈、纖瘦的旋律，也是在此時爬上思緒，裊裊盈心。既有歌曲充當乞靈的天然媒介，之後的筆觸，遂都成了「聽音樂時的起心動念」。

　　相較於歌曲的廓落與幽靜，這幅畫作的筆觸、明暗運用均更為強烈。水紋攪碎月色，糝落的銀暉一路妝點蜿蜒水路；「路」本身所承載「旅程」、「行進」、「傳輸」的意義，似乎因光影閃爍的動態感，而更顯得立體。你幾乎覺得可以躡足其上，卻又因那份目不暇給的不穩定感而卻步。永遠變動不居、曾不能以一瞬─水與月的本質畢竟如此。

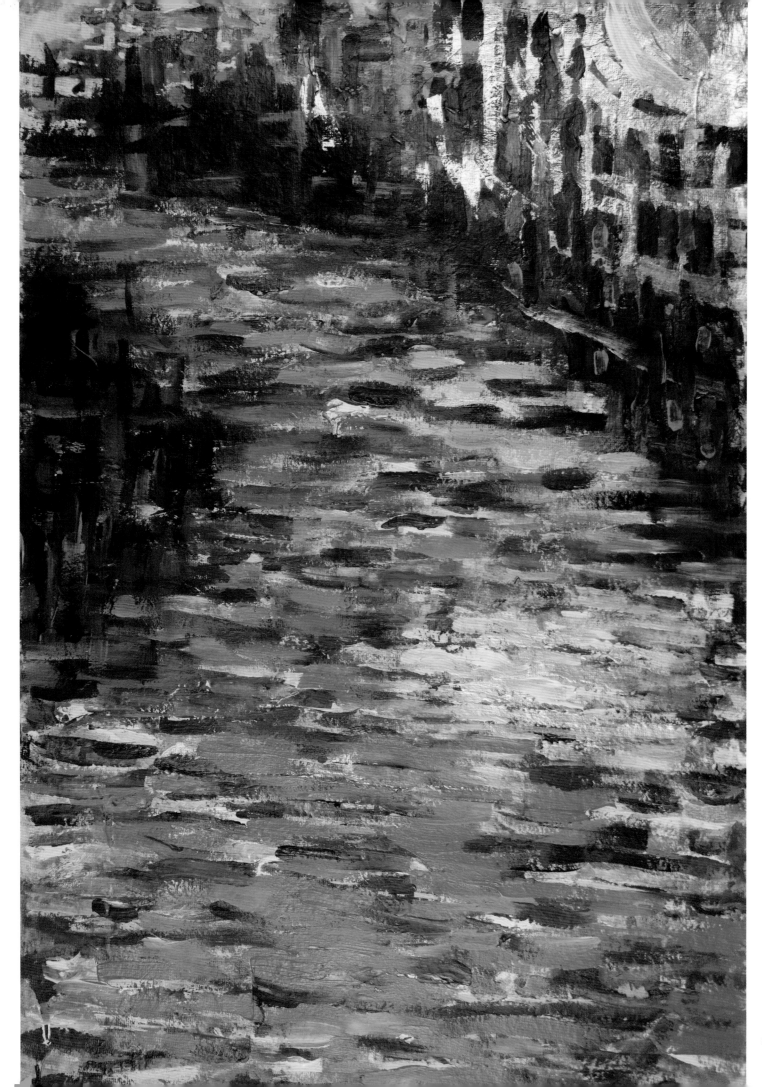

憂愁　In Sadness

廣興紙寮五彩紙　壓克力顏料　廣告顏料
65 × 65 cm
2017

　　憂愁是什麼顏色？藍、灰、或者慘白一片，大概都是與憂愁相稱的色彩。然而，這件名為《憂愁》的作品，儼然來自光譜另一端。大紫大紅，烘得人心眼俱熱；醺羹其中，觀者與憂愁的距離彌遠。

　　薰習佛學的畫家再三自陳，自己的性格中有「離於兩邊」的中觀色彩─作品中的女子似乎亦然，不倚悲喜。她嘴角的走向、眉眼的弧度，落落寡歡的雙眸、吝於抖落更多情緒線索；托腮的姿態，可以是不勝愁緒的沉重，但說是一片慵興亦不為過。

　　畫題「憂愁」二字，乾脆地揭開薛丁格的盒子，所有臆測至此似乎可以塵埃落定。但畫題會因此成為我們詮畫的原點，抑或終點嗎？一筆一畫，是否就此被收編為憂愁的註腳？以一種即非中性、也相當模稜的方式，畫家刻意淡化了畫中人的喜怒哀樂，卻又武斷地以文字為之蓋棺。就在思緒遊走矛盾與優柔寡斷之間，形似蒙德里安尼的筆觸，不經意地點出「院靜，小庭空，斷續寒砧斷續風。無奈夜長人不寐，數聲和月到簾櫳。」的孤獨與愁意。（李煜：搗練子令·深院靜）

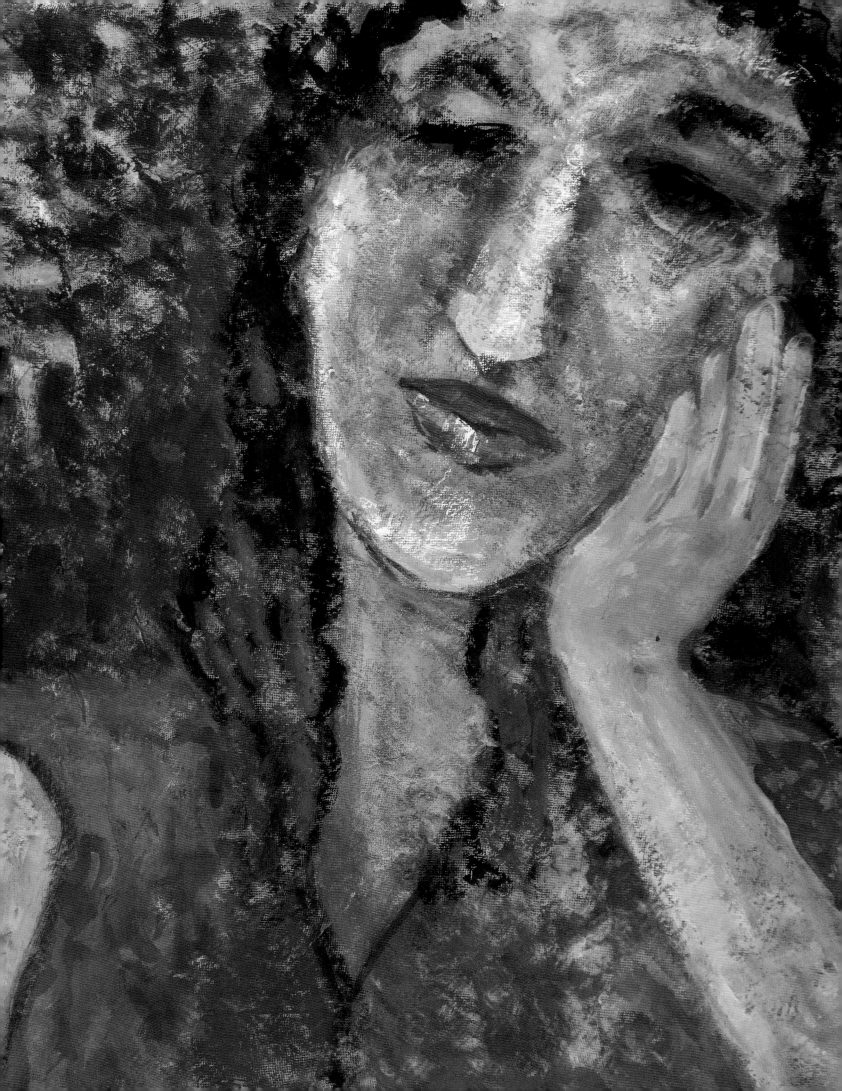

搶鏡頭 Stealing the Spotlight

宣紙 水彩 廣告顏料
137×69cm
2016

　　這件饒富中東風情的作品，催生自畫家一次杜拜旅遊的經歷。看似溫吞散漫、只宜負重踽行的駱駝，卻在觀光客快門閃爍的瞬間，以淘氣得近乎輕佻的神態，搶得一幀漏網鏡頭。向一邊撇去的下顎，為畫面添得不馴的生氣，擄盡目光。

　　第二眼，也許能很快著落在畫作耐人尋味的創作技法。本該燠熱、乾燥的沙漠，在一片毫不吝惜的濕筆中氤氳開來；若非畫家次敷以廣告顏料，讓橙黃、磚紅色系強勢主導，那水墨打底的獨特質地幾乎要予人「南朝四百八十寺」的時空錯置感。畫作場景與創作媒材，碰撞成一場妙不可言的乾濕際會；沿環狀地景由左至右，紅土建物與椰棗樹的漸次消長，再次讓「沙漠」與「綠洲」、「燥熱苦暑」與「潮溼生機」形成一種各行其是、卻又能共存共榮的奇異平衡。

　　燥濕的角力，與洋畫、國畫間的對話同步；兩股力量、兩種脈絡在畫家的斡旋下巧妙調和。也許就和那條被駱駝的齜牙裂嘴敧斜了的中軸一般，正因不諧，觀者乃被賦予更富趣味的賞畫體驗。

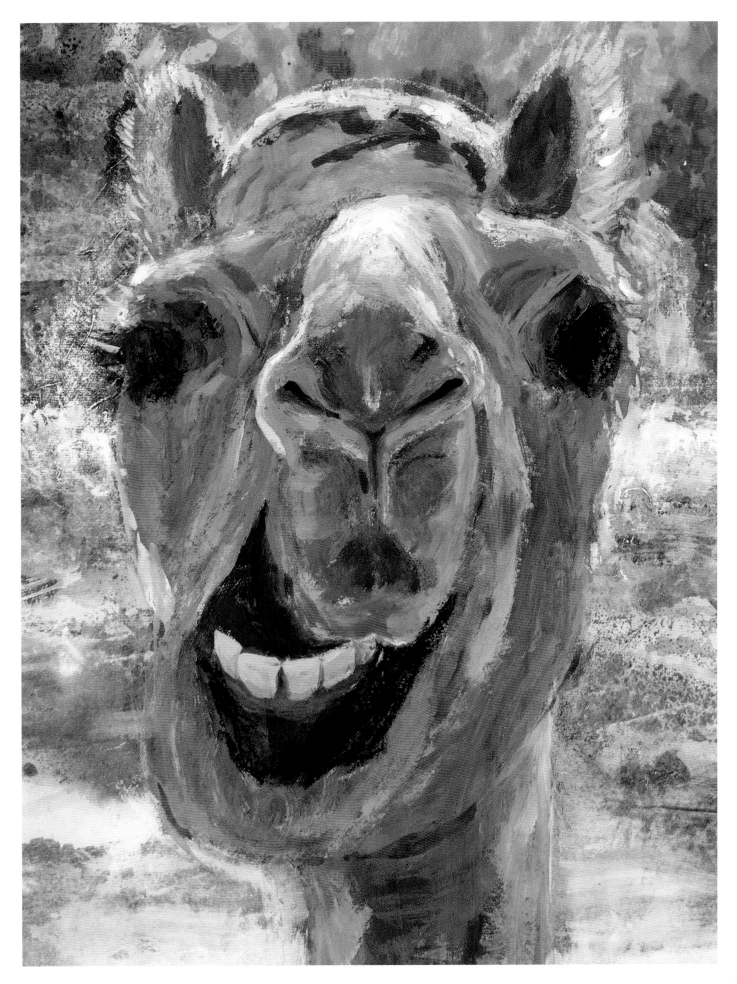

青春舞曲 Dance of Youth

廣興紙寮楮皮紙　壓克力顏料
90.5×61cm
2018

據畫家自述，《青春舞曲》是一次「為變而變」、向立體派、風格派取法的嘗試。色塊的明暗運用讓羽翼更顯剛健，昂揚的身姿指向畫面外、斜上方，飽含展望前景的意味。這件作品的用色在諸畫中較為明亮飽滿，黃、藍、綠底色拼合成一派陽光、藍天與草木交織的青春氣象；明紅鳥身同樣象徵生命力，既是形軀血氣的輻射，也是心靈熱忱的煥發。

「我的青春一去不回頭／我的青春小鳥一去不回來」──民謠《青春舞曲》如是唱道。

唱的分明是青春的輓歌，卻題為「青春舞曲」，且譜以如此歡愉的曲調。畫家從中味出的，不是暮年的自嘲，而是「壯年不再，但心境長青」的境隨心轉。曲中的元素在這幅畫中重獲詮釋：我們看到那隻正蓄勢沖霄、尚未遠飛的鳥，被包裹在忘憂的鮮嫩色海中，姿態風發。畫家彷彿在將生命中那最滿懷希冀的時刻防腐、裝幀，《青春舞曲》亦化為真正的青春頌歌，從一顆永恆年輕的心靈流瀉而出。

孫中山 Dr. Sun Yat-Sen

廣興紙寮五彩紙　壓克力顏料
98×65cm
2019

　　就《孫中山》一畫而言，大概沒有比中華民國國旗上紅、白、藍三色，更適切的配色方案。冷峻的藍色形象、不苟言笑的臉容，有意替孫中山樹起不可狎侮的威儀——但即便是在他最嚴酷的肖像中，那一對眉眼也總是儒雅、含笑，隱隱揭櫫革命家臉譜後頭，一抹風流情種的身影。我們隱約能在這尊藍色半身像中，看到一點有情有味、不那麼冠冕堂皇的成分。

　　然而，英雄難過美人關，孫中山更是嗜女近癖，連他自己都不吝承認。在他身後，浮出一張張綺羅粉黛的姣容，歷史鏡頭終於伸入那些正史闕如的角落。國旗上典正的大紅，一變而為嬌媚的茜粉，連旗面自身都彷彿成了閨房中的絳帳，營造一份深掩房櫳的私隱感。正如歷史有其淘選度，野史雜聞、街談巷議，也無不在刨根究柢的同時，篩選出最引人入勝的一二片聞，推上風口浪尖。畫中足堪辨識的，在孫中山左方，有他在日流亡期間的妻子大月薰；右方上側，是中山元配盧慕貞，下側，則是宋慶齡。除此二人，其餘女子多只是含羞半面，被化約為一對對娟麗的眉眼，退居群芳之列。對比中山向一旁漂移的目光，女子們倒是直勾勾地與觀眾對視：中山的身影固然宏偉，但在此刻的賞畫經驗中，她們才是我們忍不住一讀再讀、品玩不盡的主角，甚至多少成為掌握主控權的說書人，以她們不閃不避的視線欲語還休，吊足胃口。

　　孫中山先生以其革命領袖的身份，在中國近代史上佔據要津。但圍繞著他的感情生活，那些遮遮掩掩、虛虛實實的風流韻事，才是看客們最津津樂道的談資。這件作品要造訪的，便是那家國大計背後，遠於史詩、近於戲本的那一面；幾乎像一場因共犯眾多，多少壯了膽子、足了底氣的窺私邀約。而青天白日滿地紅，在原始設計意涵上分別對應自由、平等、博愛。此設色移植至本書，以自由之青勾勒浪子、博愛之紅描摹眾姝，意義一經疊加，更多了幾分玩味空間。

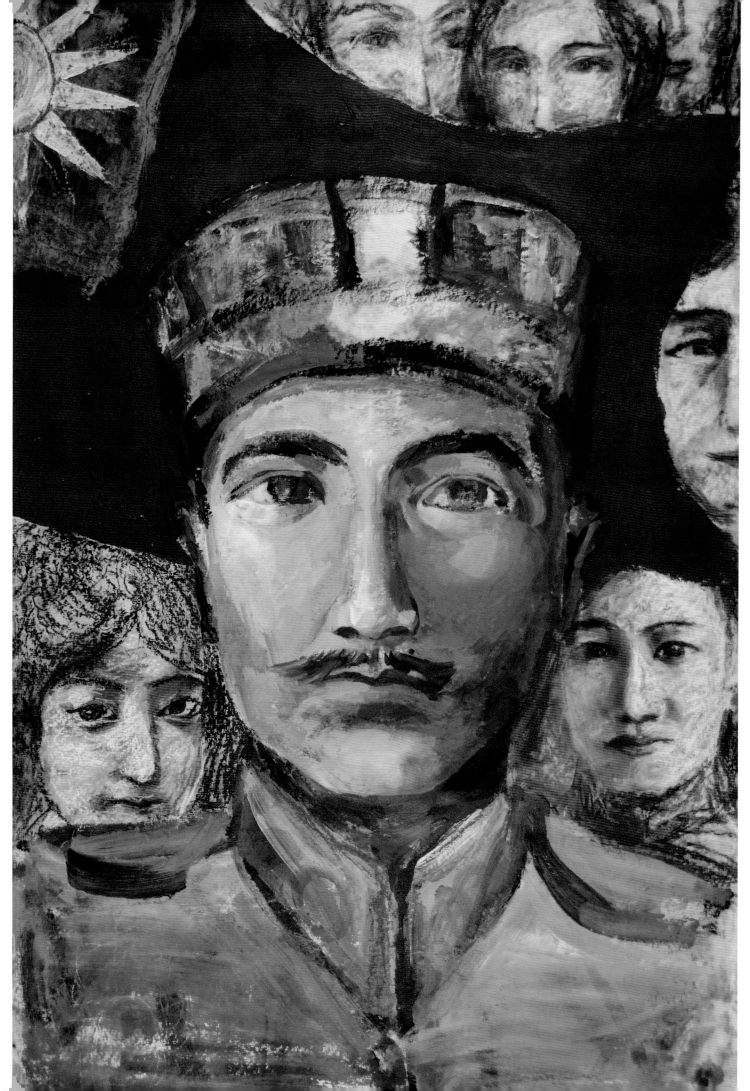

紅盒子　Red Box

廣興紙寮五彩紙　壓克力顏料
106×65cm
2018

　　臺灣民俗藝粹——布袋戲，在一代匠師李天祿的手上遠播歐陸；他也成為臺灣傳統戲劇史上，眾所仰止的一座高山。這樣一具宏大的身影，在其子的視野中，更注定避無可避。李天祿幼子李傳燦繼承了父親的姓氏，也一併繼承了他的器重與衣缽，被欽點接掌父業「亦宛然掌中劇團」。另一邊，長男陳錫煌，則帶著因過繼母系而安上的母姓，以及一只裝著戲神「田都元帥」、作為信仰象徵的紅盒子，出離家業，自立門戶。

　　陳錫煌雖未嗣承父業，但同樣操起偶桿，續寫掌中戲命脈。戲偶之神秀，偶戲之靈動，曾讓戲臺前多少觀眾目牽神隨——而也不過數十年間，戲臺下看客已稀，觀眾的目光與神思有了更新鮮、更花樣百出的去處，傳統戲曲悄然式微。

　　紀錄片《紅盒子》講述的便是這段故事：畫家觀影深受感動，以粉墨勾勒藝師精神。藝術家與藝術家間格外敏銳的共感，加上對人事代謝的飽覽，使得就中時不我與的感慨，早已溢出畫作本事、超越代位發聲。生命史凝煉為電影，電影凝煉為圖像：兩重濃縮留下的這一幀畫面，要用簡練的符號，取代生命的聲量。

　　1980年代，霹靂布袋戲用聲光點燃素樸的偶戲，使此劇種如獲新生；宛如畫中兩隻大而壯實的掌從畫外伸入，護持纖瘦、羸弱的戲偶。那是一股年輕力量的灌注、一股被期待的奧援。在奧援尚未降臨之前，近九十歲高齡的陳錫煌老藝師，只能繼續用他的暮年，力挽它的暮年。

　　布袋戲的風華與危機，老藝師的堅持與無力，在畫作中一應並呈。畫家試圖用畫筆、顏料封存其美麗與哀愁，既是悲憫，也是提前到來的追悼。

　　老師傅臉上敷色極具摩登感，幾乎像是老師傅自己的粉墨登場。傳統戲曲點翠、桃腮的彩度下行一個梯次，便踩在一種當代的、普普的、明媚而同時極不穩定的能階上；如此鮮活的色彩，鑿出的卻是一道道凝重無已的線條。操偶的兩隻手赫然抽成了操桿，藝術生命直接接壤這具有機肉體，幾乎可說是肉體生命的延伸。濁重的用色、混沌的筆觸為襯底，固然將人與偶切割為兩方議題；然而，巧妙安排的構圖：畫面左方的戲偶造型較傳統，右方則更具現代性；它們的際會，是新舊、中西交鋒前沿，一場勢不可當的更替，文化的吶喊。畫家更操弄比例，讓兩手呈現毫不相諧的大小差異。作品主題除了說明畫家對文化的關懷，整幅畫構圖比例與用色詮釋了畫家內心強烈的衝突、矛盾與孤獨感。

馬—超現實 Horses together with surrealism

宣紙　壓克力顏料　水彩
137×68.5cm
2018

　　《馬—超現實》一畫，與畫家另一件作品《搶鏡頭》頗有異曲同工之妙。在彼，是歪牙咧嘴的淘氣駱駝；於此，則是怒氣沖沖、回眸一嘶的駿馬。沿水平方向，大筆豪氣地刷開橘底，風動感應筆而生；鬃毛颯颯，迎風招展，一匹駿馬登場該有的舞台效果幾乎到位。但那排整齊列隊的齒齦，像位未及打扮，便倒屣迎客的東道主；我們本當雄姿勃發的主角，霎時回莊作諧，英氣掃蕩一空。

　　最惹人矚目、也教人費解的，要數馬額上那堆卵石。畫家媾和了質地粗實、無生命的石頭，與生氣勃勃的血肉皮毛之軀。風馬牛不相及的元素被恣意嫁接，遮蓋住局部臉容，如此荒誕的操作，教我們想起雷內‧馬格利特《人子》一畫中，那張藏在青蘋果後的人臉。那堆拒絕自我解釋的石頭，就這樣理直氣壯地存在著，格斷我們對馬的端詳，不能不予人如鯁在喉的不豫。也許更讓人難堪的是，就連作為象徵，它都很難自圓其說。畫家取法超現實主義，創造一種抗拒詮釋的荒謬性；於是一切遵循理解常規的註解、一切對符徵與符旨的探求，竟爾全告徒勞。

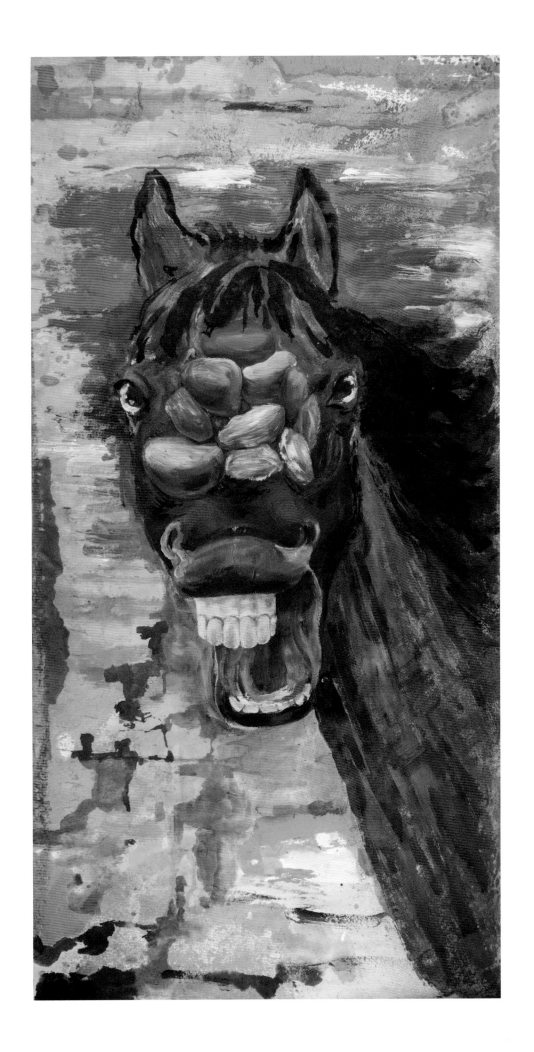

祈福之後　Pray of Blessing

廣興紙寮五彩紙　壓克力顏料
54.5×77.5cm
2018

　　美國白宮「赦免火雞」的傳統行之有年：總統於感恩節前夕赦免一隻火雞，使其免於鼎鑊之災。眾人隻手覆於雞身，宛如宗教中「御觸」的神奇療程，恩賜予火雞生命的賡續。

　　然而，天下火雞之多、饕客之眾，如何赦免得盡？畫家側寫儀式上這眾星拱月的「祈禱」一景，但「祈禱之後」呢？一年一度的赦免儀式，誠有它所宣稱的慈悲與不忍，抑或只是告朔餼羊的過場？這才是畫家叩問之所繫。

　　四隻伸入畫面的手，是要獻上莊嚴的撫觸，或是參與一場無情的瓜分？兩種並存的觀法，賦予作品一份諷刺張力。而手的主人，那些與會的嘉賓，均被排除於畫面之外，暗示行動者的想法、意圖，與行動之間的斷裂。行動成為一場面向觀者的展示——它自身即是意圖。環繞著儀式主角，七彩葉片繽紛妝點，正是一派佳節氣象；但只消再往畫面深處細看，唯見那失落了意義的黝黑，沉甸甸襯在後頭。在這一黑一彩之間，畫家對此特赦大典的想法，也許已交付顏料娓娓代言。

國家圖書館出版品預行編目資料

意象‧藝象：蘇一仲畫作品味析論 / 蘇一仲畫；
劉秋蘭作. -- 初版. -- 臺北市：藝術家, 2019.12
132面；24×29公分
中英對照
ISBN 978-986-282-243-2（精裝）

1.繪畫 2.畫冊

108020494 947.5

意象‧藝象
蘇一仲畫作品味析論

發 行 人｜蘇一仲

作　　者｜劉秋蘭

英文翻譯｜劉國明

資料編輯｜鍾浩齡、陳沐昭、賴芊卉

美術設計｜賴芊卉、郭秀佩

文稿口訪｜陳沐昭、賴芊卉、鍾浩齡、劉秋蘭

攝　　影｜鄭國裕

印製單位｜藝術家出版社

　　　　｜地址：臺北市金山南路（藝術家路）二段165號6樓

　　　　｜電話：02-2388-6715‧2388-6716

　　　　｜傳真：02-2396-5708

　　　　｜郵政劃撥　50035145 藝術家出版社帳戶

總 經 銷｜時報文化出版企業股份有限公司

　　　　　倉庫：桃園市龜山區萬壽路二段351號

　　　　　電話：02-2306-6842

製版印刷｜科億彩色製版印刷股份有限公司

初　　版｜2019年12月

定　　價｜新臺幣 800 元

I S B N　978-986-282-243-2